Cherry Morton
Ex Libris

In Irina's Garden

WITH HENRY MOORE'S SCULPTURE

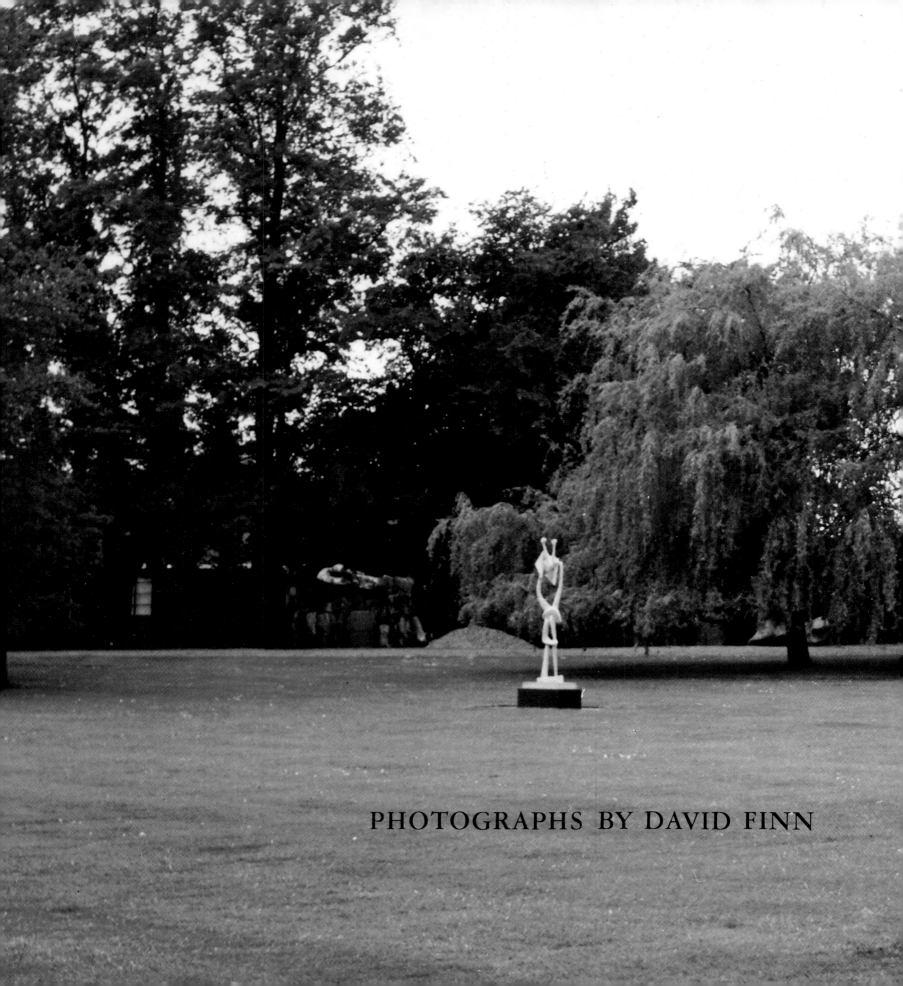

PHOTOGRAPHS BY DAVID FINN

STEPHEN SPENDER

In Irina's Garden

WITH HENRY MOORE'S SCULPTURE

THAMES AND HUDSON

ACKNOWLEDGMENT

The publisher would like to acknowledge with gratitude the
generous assistance of the Henry Moore Foundation in
the publication of this book.

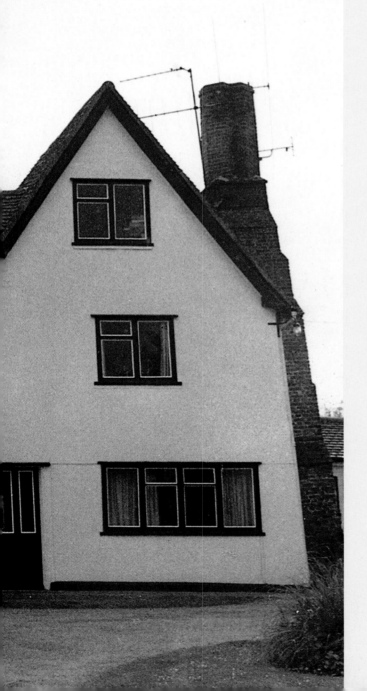

CONTENTS

LIST OF
ILLUSTRATIONS

PREFACE

by David Finn

There is a whole library of books and catalogues on the work of Henry Moore, but none on that of Irina Moore, and yet it is she who has played a big part in creating the environment in which for over fifty years he has been able to produce his works. This book is intended at least partially to fill that gap.

All who have visited the Moores in their home at Much Hadham in Hertfordshire will know that the woman who is Henry's wife and close companion has always been a major presence in his life. The Moores have welcomed visitors, whomever they may be and wherever they may come from. These visitors have included heads of state, as well as fellow artists; students, collectors and museum officials, as well as local people.

Over the years one of Henry Moore's favourite ways of spending time with guests has been to take them to see the works in progress in his various studios. On the way he would inevitably point with pride to the gardens around the house: the lovely groves of trees, the hedges that so skilfully mark off sections of the grounds in which one or another of the large sculptures are placed 'All this', he would say admiringly, 'is Irina's doing. It's marvellous what she has been able to accomplish. There was nothing here when we started — nothing — Irina did it all.'

My wife Laura and I first met the Moores in the late 1950s. When they were younger and perhaps more vigorous we would always find Irina working in the garden and Henry working in his studio. What has been so special about their relationship is the respect each has

shown for the working life of the other. Although Henry's sculpture, drawings and prints commanded worldwide attention, he did not give the impression that he considered them more worthy or important than Irina's work in the garden or the house. Both had their occupations and each loved what he or she was doing; each was of equal importance in the Moore house.

Because I came to appreciate Irina's gentleness, kindness and warmth, I began taking photographs of her garden a few years ago as a mark of my admiration. I had long been taking photographs of Henry's sculpture and I wanted to surprise them with photographs of Irina's artistic achievements. When I made some large prints to show them, they were delighted.

Irina has always disliked being photographed and has insisted on staying out of the limelight. She has avoided as much as possible attending exhibition openings of Henry's works, has not given interviews and has adamantly refused to appear in the more than thirty films that have been made about her husband's work. So I am especially fortunate to have prints of four photographs taken of her a few years ago by my daughter Amy, which Irina does not object to and which are reproduced here. When I broached the idea of doing a book on her garden Irina was characteristically reserved, and said she would think about it. Henry was in favour of the idea if Irina approved.

I kept taking more and more photographs in the months that followed, and Irina kept thinking about it. Finally she gave her approval on one condition, namely, that the book should be simple and unpretentious. Her garden could not be described as an elaborate affair because it was not. It was a garden that anybody who lived in the country and who loved flowers and trees could make.

One afternoon I asked Irina to record a conversation with me about herself, her home and her garden. Her words are transcribed in the 'Reminiscences' published here. They tell her story as only she can.

Irina Moore is an exceptional human being. I hope this book will serve as a tribute to her creativity, her achievements, and her extraordinarily fruitful life.

Pp. 12-15: Irina Moore in her garden; Henry Moore's drawing studio (left) and maquette studio (right); and Henry Moore in his drawing studio ▷

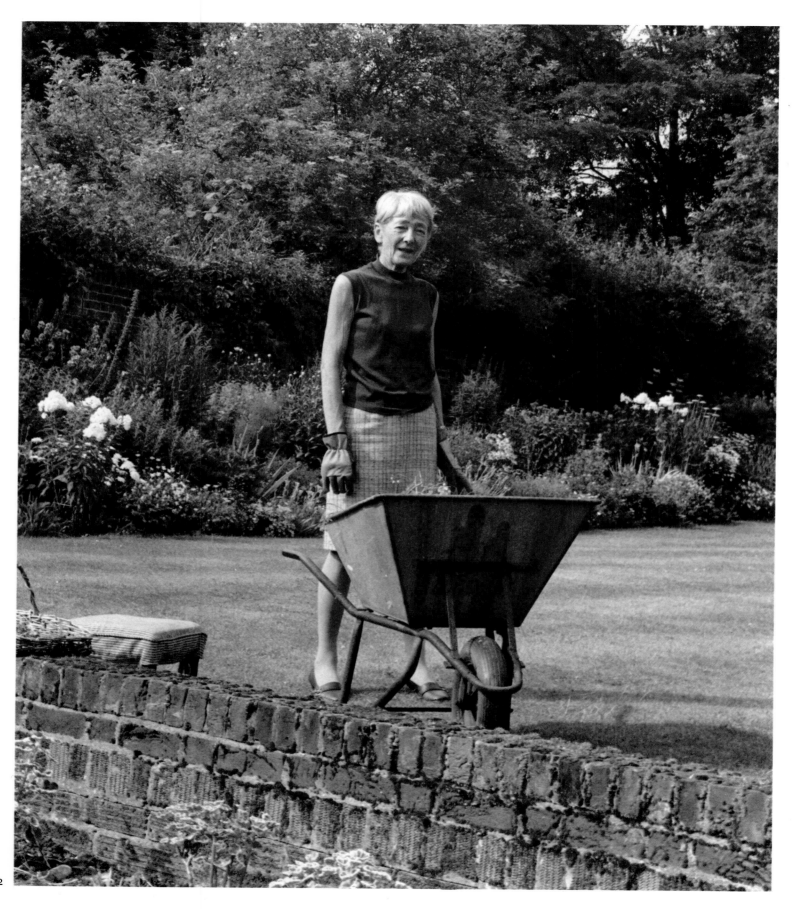

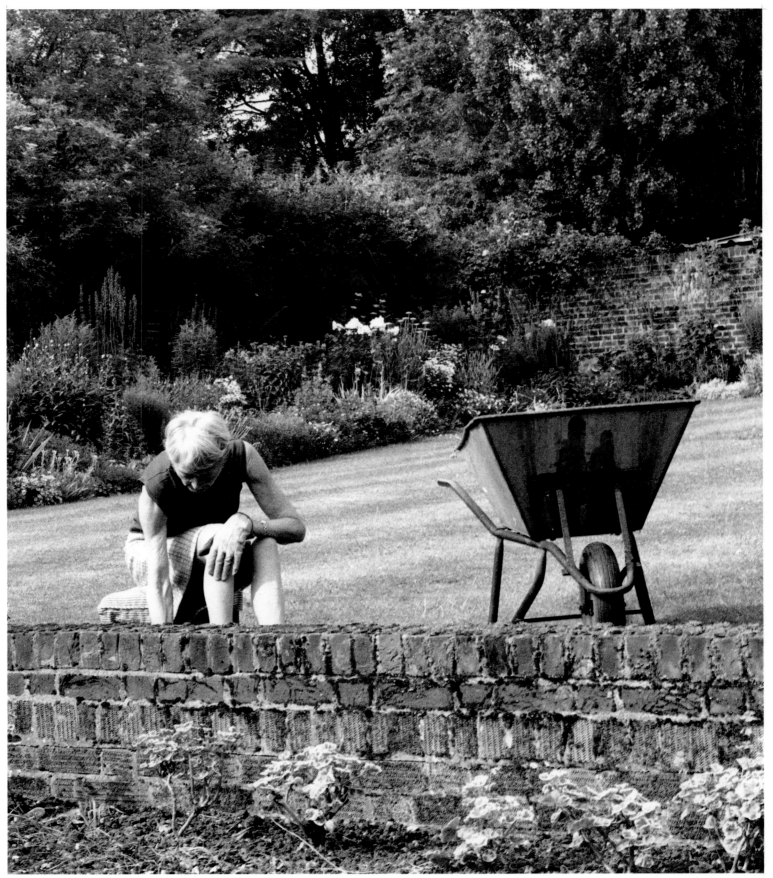

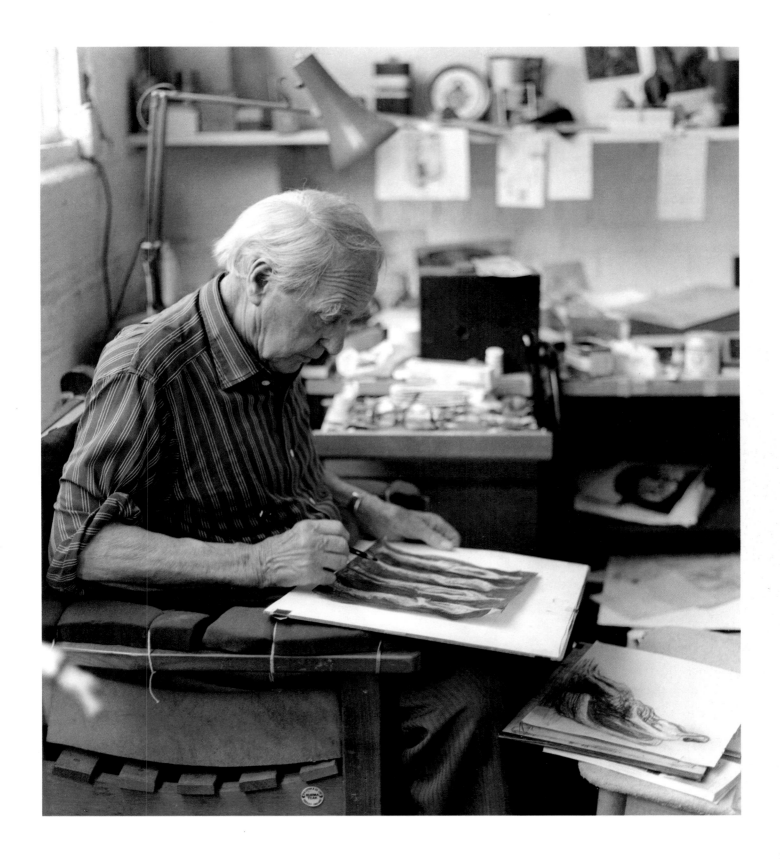

THE HOUSE

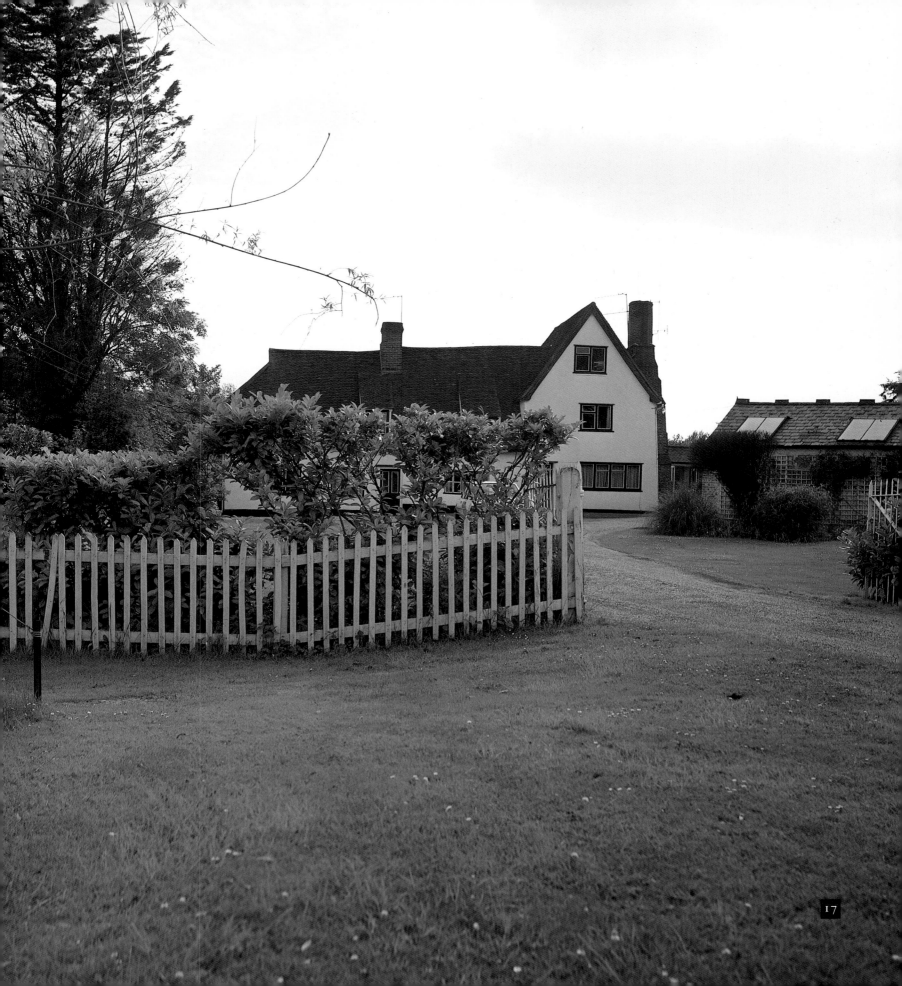

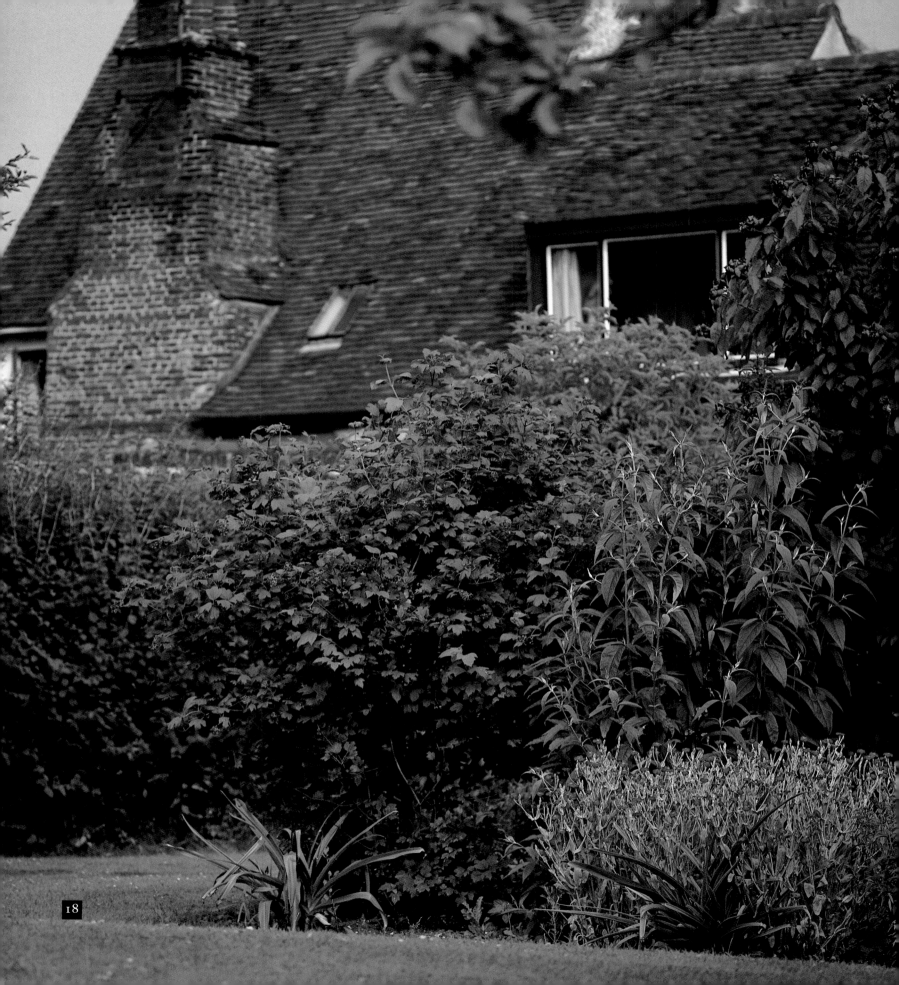

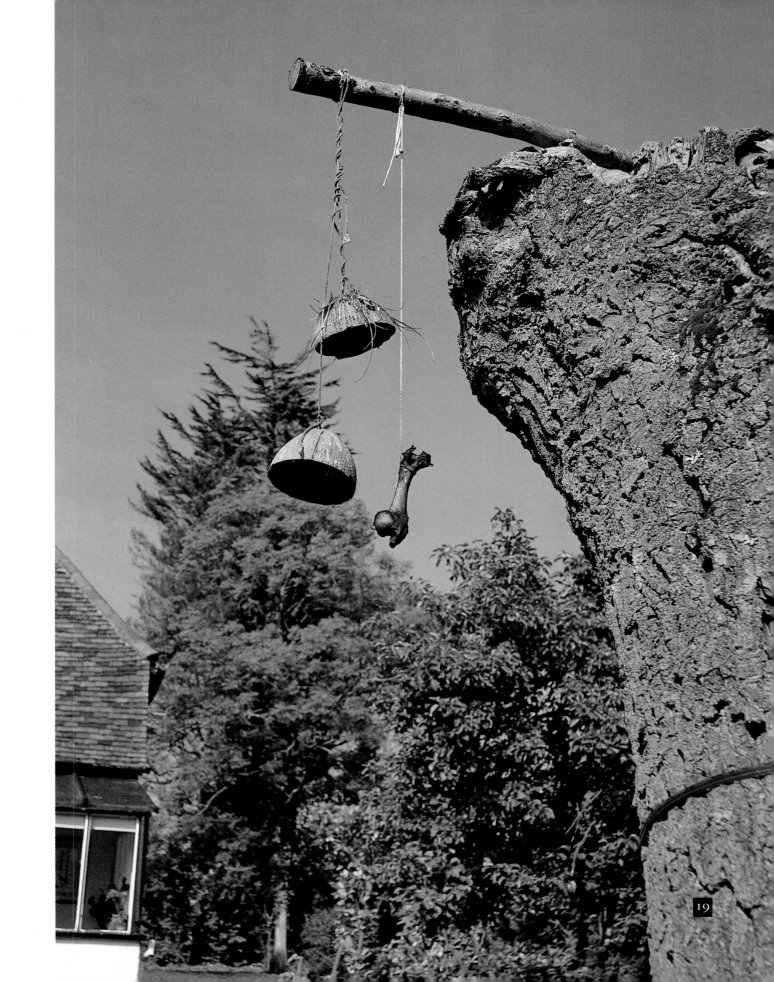

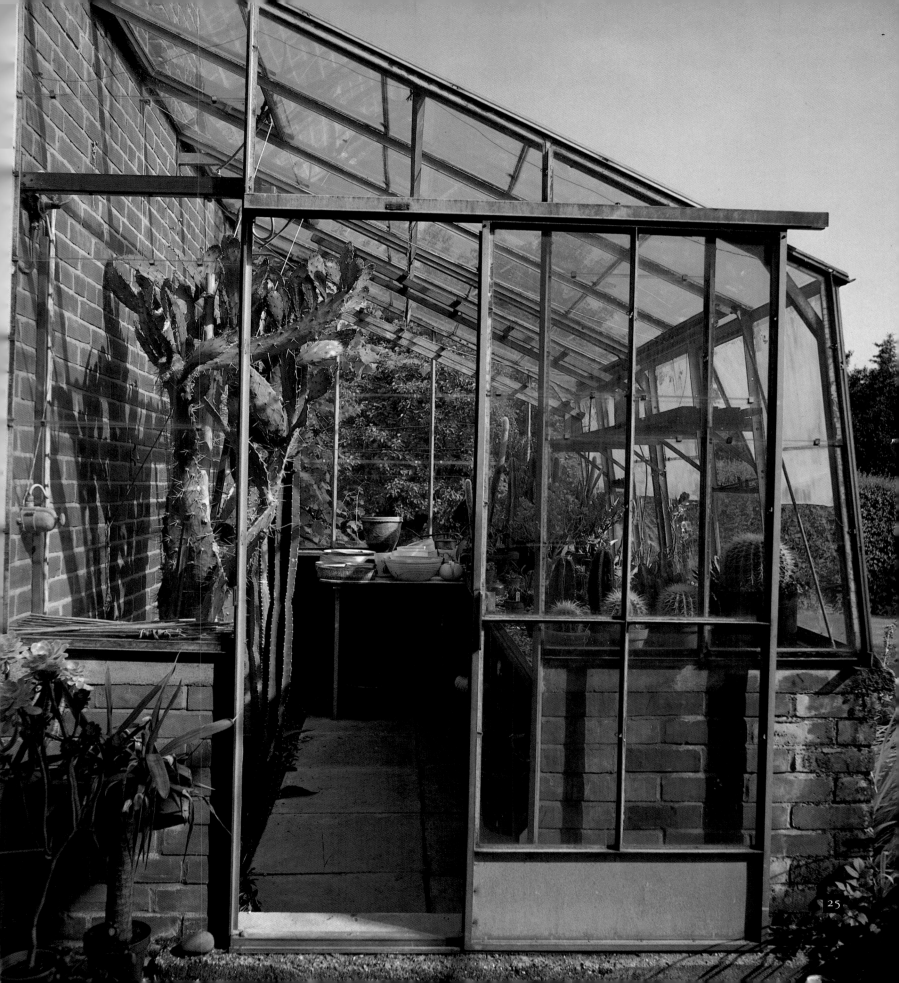

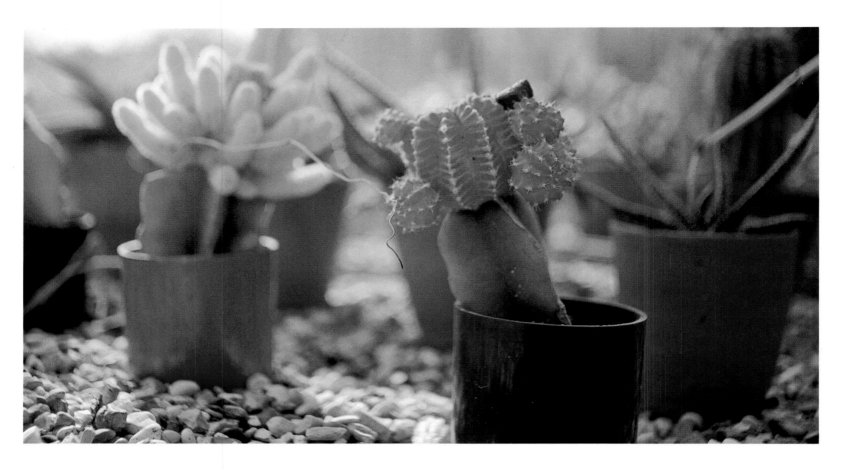

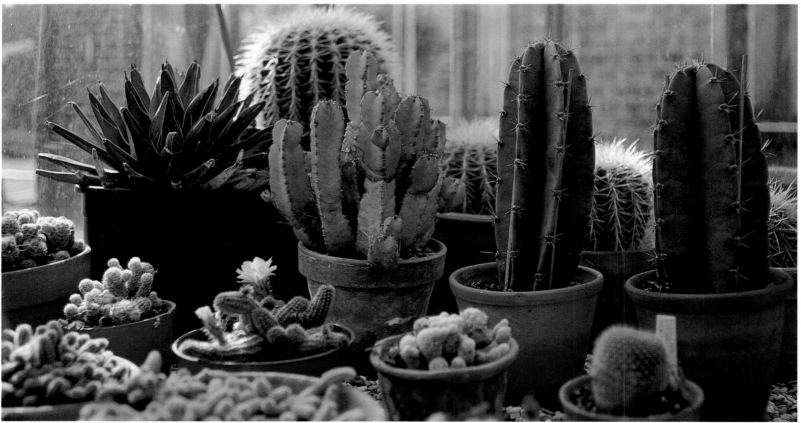

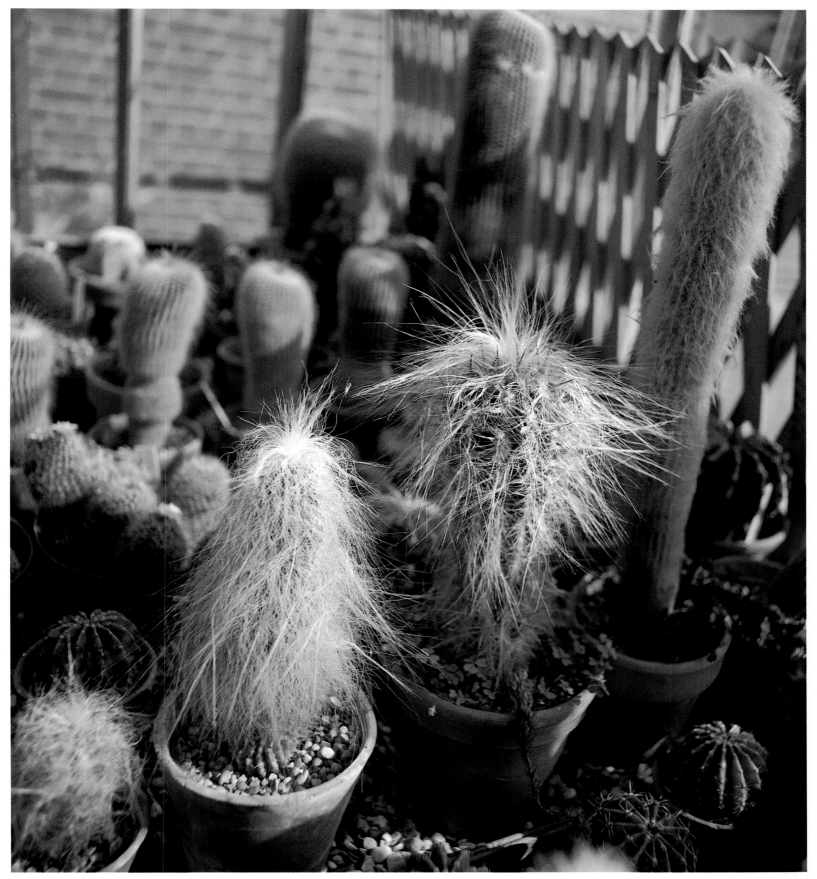

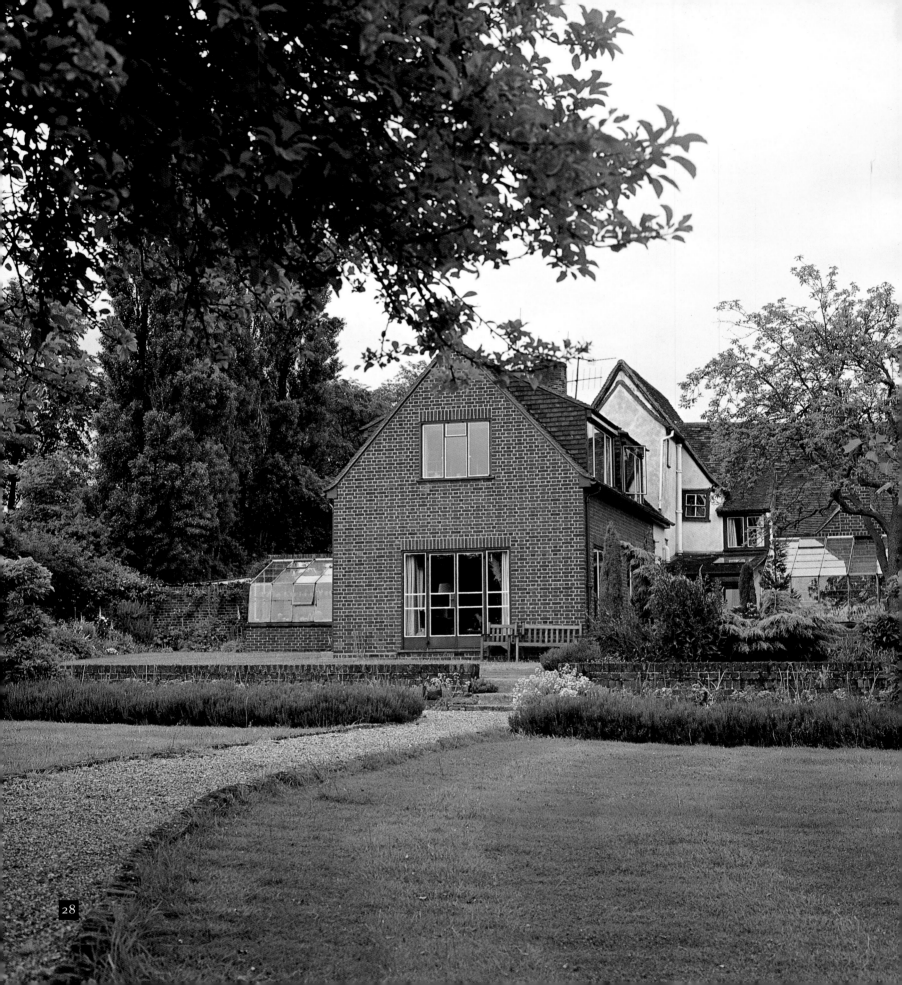

'HENRY AND IRINA'

by Stephen Spender

I first met Henry Moore in 1933. He was thirty-four, ten years my senior. I think that we were introduced by Herbert Read, whom I had met some months earlier, after the publication of my first volume of poems. Shortly after meeting Henry, I was asked by the editor of a literary periodical, the *London Mercury*, whether I would sit for an artist who was doing a series of portrait drawings of young writers for them. I said that I would only let the *London Mercury* publish a drawing of me if it was by Henry Moore. This was impertinent. When they approached Henry, though, he was amused and agreed. I sat several times for him. He had the idea of doing studies of my head, from different angles, on the basis of which he would make a cubistic drawing which combined all these. After one or two attempts he abandoned this idea and sent the *London Mercury* one of the studies, which they published.

We became friends. I went several times to see the Moores at their apartment at Parkhill Road, Hampstead. Sometimes when I was there, the Moores' neighbours Ben Nicholson and his then wife, Barbara Hepworth, after a day's work, would come to Henry's studio. They would show each other work in progress. Ben Nicholson was at that time doing his bas-relief squares and circles. There was a feeling that all art by these artists should be abstract. Henry felt under some pressure also to do abstract art. He told me later of his disappointment then with himself that however abstract he tried to be, his work always 'turned into something', a Reclining Figure, for example.

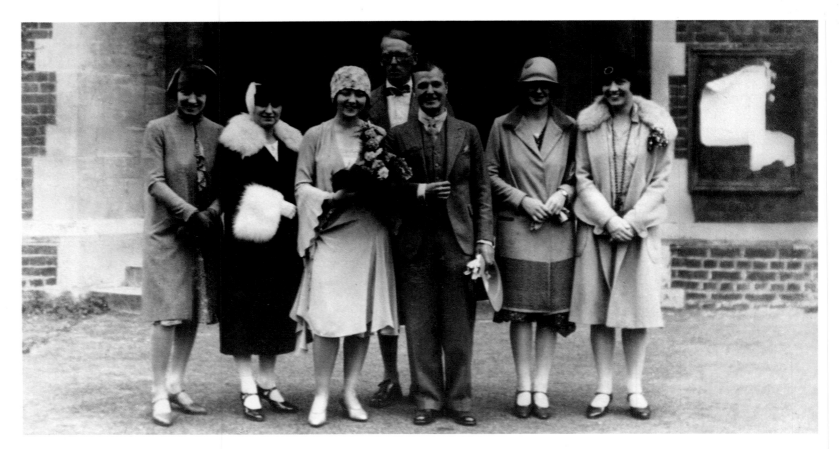

The wedding of Henry Moore and Irina Radetzky, 27 July 1929 (Henry Moore Foundation Archives)

Herbert Read sometimes appeared at these informal gatherings, a chivalrous Knight of the avant-garde. Other friends and neighbours of the Moores were Geoffrey Grigson, editor of *New Verse*, and notorious for his scalding attacks on poets whose work did not meet with his approval, but the most mild-mannered of men; and Edwin Muir and his wife, Willa. Edwin Muir was a literary essayist and autobiographer, just then beginning, rather late in life, to write a very distinguished body of poetry. Willa was a forthright Scot with an accent like a sledge-hammer in which she pronounced sledge-hammer judgments. She was assumed to have a heart of gold and Edwin lived in a kind of bemused loving awe of her.

This intellectual and artistic Hampstead neighbourhood brought to mind the same part of London more than a hundred years earlier, when Leigh Hunt and Keats lived nearby and when, on one occasion, the megalomaniac artist and excellent autobiographer Benjamin Robert Haydon gave a famous dinner party for Wordsworth which was attended by Charles Lamb, Shelley, Keats and an official from the Stamp Office.

At their studio parties Irina Moore was always very present yet somehow also always a figure in the background. It is difficult to describe Irina as she was then except in terms of contrasts — contradictions almost. She was beautiful, without being in the least a Beauty, striking in a way that made one reflect that one might be the only person in the room to notice her (but every man present might be thinking the same thing). Irina seemed rather silent and never, that I can remember, joined in those discussions about art — abstraction, functionalism, the work of Kandinsky, Paul Klee, etc. — which formed topics of conversation. Yet whenever, as sometimes happened, I bought a drawing from Henry, I always asked Irina to help me choose, feeling that she had good judgment of her husband's work, though she never expressed an opinion about it unless asked. To her, surely, sculptures and drawings were, like everything else, simply 'Henry'.

Irina had — she still has — features that make one see at once why an artist (and, in particular, a sculptor) would adore her — not that she looked at all 'artistic'. She is an almost anonymous presence felt in Moore's early sculpture of figures of girls.

Although giving this impression of silence, Irina enjoyed amusing gossip and was — is — I think interested in the visitors to the Moores. She inhabited the inner world of her own thoughts, but nevertheless figures such as Kenneth Clark — and, still more, his wife, Jane — Philip Hendy and David Sylvester loomed quite large in it. Occasionally she made acute remarks about them. I felt that she quietly divided visitors to their studio into those who were Henry's friends and those who were not quite such friends. She seemed a good judge of people, as of Henry's work, but I never heard her pass judgment on anyone. Apart from her constant awareness of Henry, she seemed a spectator.

Writing now about Irina, I think — especially after reading her 'Reminiscences' printed here — that it is not at all irrelevant to point out that at this stage of Henry's career — although he was already a well-known and sought-after sculptor — examples of his work were rather easily obtainable by those who cared for them, even if the purchasers were comparatively impecunious. By saving up a bit, a poet, a literary journalist, or a schoolteacher could afford a Moore. I bought two of Henry's studies of me and another drawing, at £5

The studio flat at 11a Parkhill Road, off Haverstock Hill in Hampstead (Courtesy of Gemma Levine)

apiece — a reduction of 50 per cent it seems (for Irina states that drawings cost £10 each). I mention these matters for two reasons: first, because the Moores have always seemed to fit harmoniously into their material circumstances, however limited or however expansive these might be. They seem always only to have wanted money to do what they could satisfactorily do on however little or however much they had, which was for Henry to get on with his work, and for them to be able to entertain a few friends at the end of each day.

My second reason is that I seem to detect a note of nostalgia in Irina's piquant interview, nostalgia for those early days when

View of the studio at Parkhill Road (Henry Moore Foundation Archives)

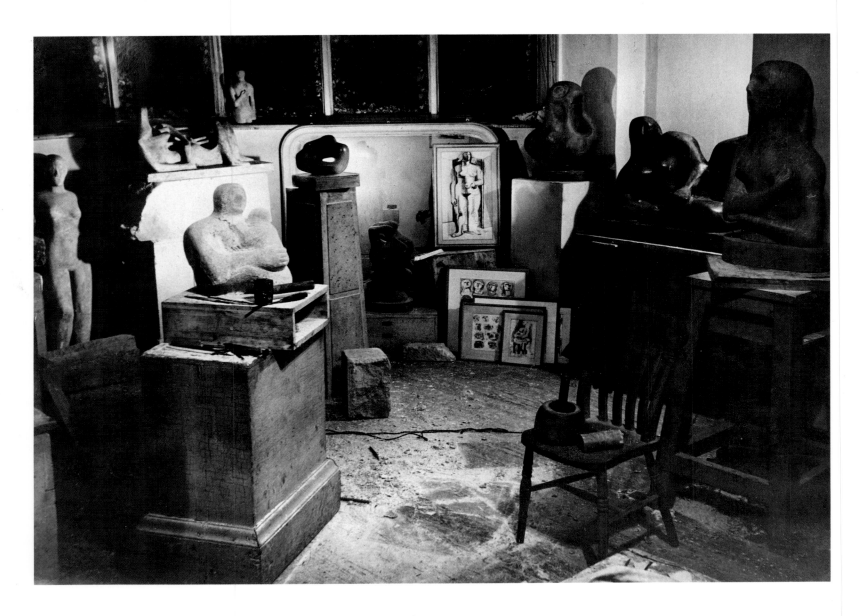

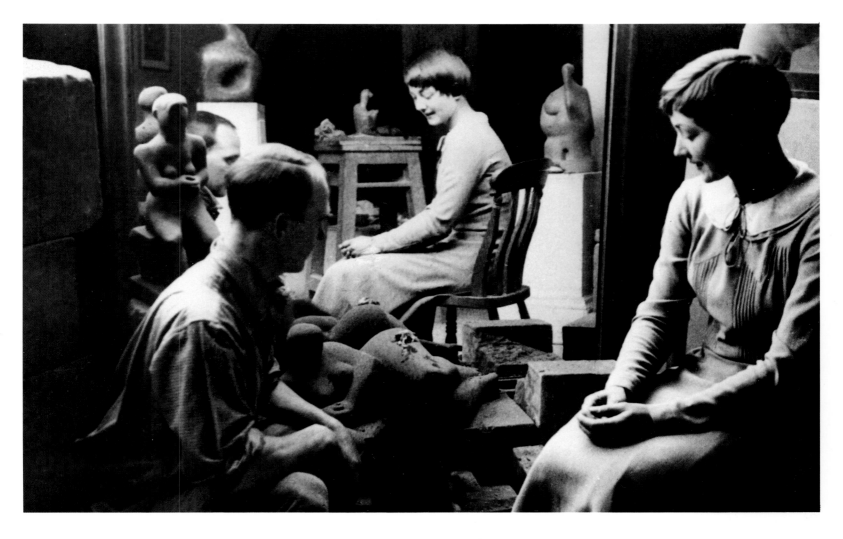

Henry and Irina in the Parkhill Road studio flat
(Henry Moore Foundation Archives)

everything was work and rest and camaraderie with fellow artists and somehow shared – and the world had not turned Moore into an institution. The philosophical detachment with regard to success or failure, poverty or affluence, which Irina clearly regards as hers temperamentally, throws light for me on an image I have always carried round in my mind of Henry and Irina. It is of them sitting side by side in rooms of different sizes – first quite a small room in which everything was going on in that one room, and, last of all, a very large room, leading into other rooms and wide outdoor spaces and studios beyond: but always they are together quite in the manner of one of Henry's Family Groups – a third figure being most happily added to the couple after the war, when their daughter Mary was born. The fact that the group, in whatever circumstances, seems at all times the same, I attribute as much to Irina and her view of life

33

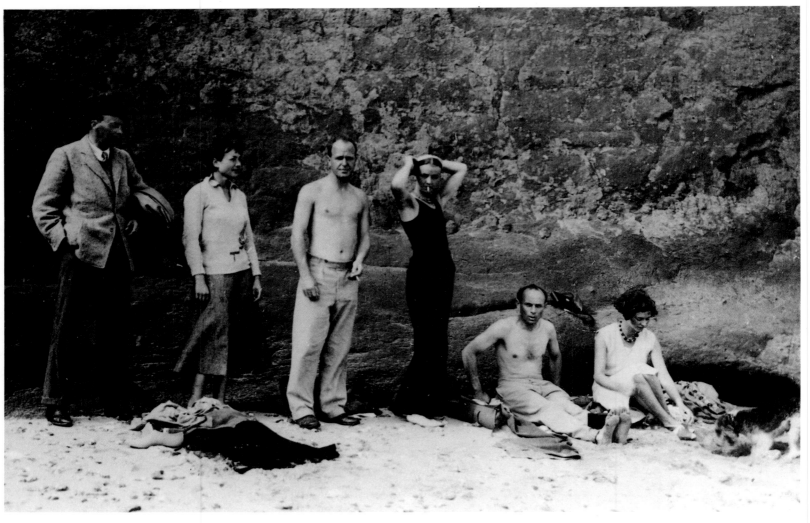

Gathering of friends on the Norfolk coast in 1931, photographed by Douglas Jenkins. Left to right: Ivon Hitchens, Irina Moore, Henry Moore, Barbara Hepworth, Ben Nicholson, Mary Jenkins (Henry Moore Foundation Archives)

as to Henry, who in his life and work has projected just such an image of the family, secular and yet holy.

The war scattered the Hampstead friends and colleagues, altering the pattern of everyone's life. As Irina notes, Ben Nicholson and Barbara Hepworth went to St Ives, while Henry and Irina moved into the studio they had shared in Parkhill Road. Meanwhile, Henry's friend and patron, Kenneth Clark, then at the Ministry of Information, set up a programme for artists to produce works related to the visual transformation of many aspects of English life resulting from the war. As War Artist, Henry Moore made his famous series of Shelter Drawings of Londoners who, during the Blitz, took shelter in the underground stations of the Metropolitan Railway.

In 1940 – just as Irina describes it – a bomb shattered the Nicholson studio. The Moores left London and stayed with friends in Much

Hadham in Hertfordshire. Soon after this, they bought Hoglands, then in a terrible state of disrepair, but which, with continuing additions and alterations through the years, was to remain their home right up to the present day.

I happen myself to know this part of the country rather well, as, when I was a small boy, I often used to stay in the house of friends of my father at Widford, which is only five miles or so from Much Hadham. The countryside has altered remarkably little since then. It is mostly flat, sparsely wooded, with winding lanes and occasional little hills: poignantly green in summer, black and white and stark as a woodcut in winter. The village of Widford, where I used to stay, runs either side of the road to Hertford, two lines of white or pink or yellow, painted or stucco houses, several of them timbered, and a pretty church. This countryside seems of an older England, some of it Elizabethan (Irina says that part of their house dates from the fifteenth century). Perry Green seems to radiate hiddenly from a very small village green which fronts Hoglands, the Moores' house. In spring and summer it is one of those English villages which seem lost among green branches. But there is, or was, quite an active village life, in which the Moores, when they were a bit younger, used to participate. When my wife, Natasha, and I visited, Irina used to serve us tea with cake or scones bought, she explained, at the village Women's Institute.

The house, and the acre of land, which they bought at the same time, formed a nucleus, a cluster to which further units — consisting of rooms and furniture and art treasures and the garden and, beyond it, fields with Henry's sculpture in the landscape — have accrued across the years.

This seems a natural organic growth, not an amassing of things for the sake of owning them. I think that anyone who has known Henry and Irina for many years must feel that they share some secret which has prevented their true values from being distorted by possessions or success. Friends must attribute this to some kind of sacred simplicity of greatness which Henry Moore has had perhaps throughout his whole life. He does not indulge in revelations about himself: nevertheless, he sometimes lets drop an observation which is more remarkable than some thought-up instance of the extraordinary. For example, he once told me — as something which rather

surprised him — that he cannot remember at any moment of his life feeling that anyone he met belonged to a class either inferior or superior to himself. Moore does have a sense of his own genius. But social distinctions do not exist for him — he believes that he belongs to the human race.

And Irina's 'Reminiscences' show that she regards money and success as things given and taken away. So what can they matter?

Kenneth Clark once remarked to me that if the inhabitants of this Earth found themselves in the position of having to send an ambassador representing the human race to the inhabitants of another planet they could not choose better than Henry Moore. What Clark meant is that Moore combines the qualities of the man who is creative — an artistic genius — with those of an entirely human being. In him the two are identical. And perhaps Herbert Read was expressing the same thought — as it were reversing it — when he said to me once (we were looking at a Moore bronze entitled *Three Quarters Figure* which seems part animal, part human and, perhaps, part rock face) that Henry Moore was the one and only true Surrealist, by which he meant that Moore instinctively interpreted unconscious dream into artefacts of conscious craftsmanship. In the best of Moore's work, the dark and primitive unconscious is transformed into the shared consciousness of the profoundly human. There is a kind of coincidence of opposites as though the artist's individual vision which refused to recognize any kind of social responsibility proved, after all, to be the most responsible socially because in his artefacts it expressed the artist's humanity.

What strikes one about Moore the artist is the originality; what strikes one about the man is the humanity: and, putting the two impressions together, both the man and the work — the man in the work — suggest a kind of ideal norm of individual man as creative, imaginative, responsible, and even, in some profound sense, ordinary.

Researchers interviewing Moore about his art are, I think, baffled on occasion when he cannot enlighten them on the surrealistic, dark aspects of it — cannot provide a reason for the famous 'holes', for example. To Moore the darkness is inseparable from his total vision. It appears inevitable to him that his sculpture should be at once highly conscious and intuitively unconscious — at one and the same

time civilized and primitive. He cannot provide self-analysing Freudian explanations for the inevitable in his art. And he has always suspected that if he did do so his work would lose spontaneity.

Henry's attitude to the quite overwhelming world-success that came to him in the post-war era (particularly in the 1950s) was to enjoy with gusto the opportunities for seeing people, places and works of art which it offered. He accepted the role of being one of life's honoured guests without surprise and without having his head turned. He gleaned experiences from what he saw abroad which contributed to his own work. For example, after a visit to Greece he started sculpting draped figures. Yet, when abroad, what he most wanted was to get back to Much Hadham — to Irina and their daughter Mary — and to get on with his work.

Irina extended the garden which she had been making ever since they first lived at Hoglands during the war, when she grew vegetables there. One is tempted, almost, to think of the growth of Irina's garden as her answer to the externalization and extension of Henry's life and art which his fame imposed on him. Going through the garden once in order to look at the sculpture, Henry remarked to us that for Irina her plants were as important as his sculpture was for him. But today Irina's garden occupies only a small vestibule-like entrance to the whole area of fields and a small, disk-like hillock beyond, where sheep graze among Henry's sculpture. Reading her 'Reminiscences', I am touched by her insistence on the casualness of her gardening — she plants what she likes . . . plants that seem easy to grow — and anyone who cares to might do the same. This gives me a curious feeling, similar to the feeling I get from her description of first meeting Henry when they were both at the Royal College of Art and her thinking on learning that he was a sculptor — well, that is something a young artist might be.

Irina's garden is a setting for Henry's sculpture — for some of it — and there is something in this which symbolizes their marriage, with Irina working in her part of the garden and looking beyond to a countryside of fields in which there are several works of Henry's, some of them very large.

It must be forty years since we first visited Henry and Irina at Hoglands. By the time we did so, which was after the war, the house (apart from the large sitting room — the New Room — which today

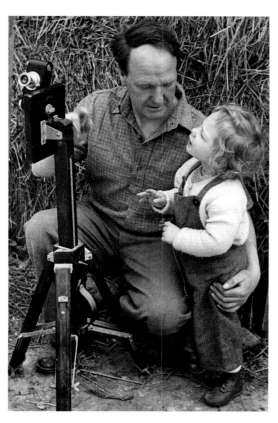

Henry Moore with his daughter, Mary, in 1948
(Henry Moore Foundation Archives,
© Felix Mann, 1986)

they mostly live in) was complete, together with Henry's only studio, at the side of the house, which later came to be regarded as the small studio for maquettes. Besides these, there were *objets trouvés*, curiously shaped flints and other stones, bones, shards, etc., on shelves and in cupboards: things which sometimes suggested to Henry ideas and motifs and which, in one instance at least, became assimilated into a work of sculpture. For the seated figure of a warrior holding up a shield began as a maquette incorporating a flint shaped like a thigh bone, upon which Henry constructed in clay the rest of the figure.

My wife, Natasha, who shares with Irina a passion for gardens and gardening, tells me that she remembers seeing by the side of the studio 'an extremely happy chaenomeles (Japanese quince) glowing red in bloom – and with new foliage tipped with the same colour'. The very first day we went there it occurred to her that the shrubs in front of the house looked particularly happy and well cared for. Afterwards she said she realized at once that someone in the house must have a peculiarly warm relationship with plants. This was, of course, Irina.

In her 'Reminiscences' Irina relates that about fifteen years after they had bought the house they added on to it what they called the New Room. Very soon this was to become, for visitors, the central feature of the house. Large, light and airy, with walls that over the years became more and more covered with pictures, and tables more and more crowded with objects (all of which seemed of a kind one would like to take up in one's hands and touch) – the New Room became Henry's and Irina's place for receiving guests. Here, after viewing the garden, touring the studios, and seeing works in progress, one could settle down with Henry and Irina and enjoy a cup of tea, or drinks – and talk about old times.

Of course the building of the New Room, which jutted out from the house at right angles, considerably modified the shape and area of Irina's garden. A path running from the old part of the house alongside it was paved. To the left of this path, as one leaves the house, Irina planted a flower border with, beyond it, a line of ancient-looking apple trees. Colours of the flowers in the border reflect in the long narrow windows of the New Room. Walking to the end of this path, away from the house, one sees straight ahead a

line of espaliered apple trees with, shining beyond them, an expanse of green lawn where at intervals there are pieces of sculpture and the Moore sundial. Immediately beyond the espaliered apple there is an old plum tree laden with fruit, and to balance it in size and form Irina planted a tulip tree. To the right of the New Room is a walled border which at its peak in the month of June is composed almost entirely of pinks and blues – in late August the blue of echinops (globe thistle).

The flower bed along the paved path prepares one thematically for sculpture, in its contrasts of form and texture, as well as of colour. Knife-edge foliage of iris and montbretia asserts itself against the rotundities of opulent tree-peonies. There are spotted pulmonaria next to needles of herbacious polygonum and clouds of rue. A vertical juniper and a horizontal one, growing together, lead to the long path that crosses the lawn where the sculpture is displayed – a programme which has changed for us across the years as some pieces have been taken away and replaced by others. But there stays in my mind, seen on our right, going down the path, a bone-coloured dark-textured cast of the great *Interlocking Form* piece, a bronze cast of which stands on the Thames Embankment near the Tate Gallery. At one time the elongated *Knife-Edge Figure* also stood in the garden – its turning and twisting pose like a skeletal ghostly ballerina. Mention of this piece reminds me that some time after the war, builders working in the garden unearthed an immense quantity of bones, relics of an ancient slaughterhouse. These fascinated Henry, partly because they seemed to throw light on the strange name of the property they had bought – Hoglands.

One day, visiting the Moores, we walked from the house to a stretch of land they had recently acquired beyond the espaliered apple trees. At that time it was still a long, oblong, featureless field, with an awkward chunk cut out of it by a neighbour's somewhat neglected apple orchard. It was certainly difficult to imagine how such an unprepossessing space could ever be redeemed and brought within the unity of the whole garden. I remember Henry on that occasion telling us how, together, Irina and he had sited the trees, and his saying how excellent Irina had been at visualizing just how they would look when they were fully grown: as, indeed, now they were grown, we could see for ourselves. For they formed the most

appropriate and fitting natural islands of foliage resting the eye as we walked from one sculpture to the next. There are no exotic species here. Native trees predominate – silver birches, poplars and willows, with here and there an acacia.

More recently, we saw another example of Irina's gift for planting appropriate combinations of form and texture. A double line of quickthorn hedges leads the eye to the *Interlocking Form* sculpture. This provides a rare example of geometric curved line; elsewhere the lines are more fluid. On the whole, in Irina's garden one is conscious more of mass and texture than of line. A long, gently serpentine border of trees and shrubs to one's left as one walks down from the house past sculptures and towards studios, with, beyond them, more sculptures placed in fields, provides the kind of effect at which Irina excels. Nothing that is here obtrudes, yet, walking up to the border, one discovers many treasures.

The gentle variation of texture – sumachs, brooms and purple prunus, with here and there a splash of light foliage of variegated elaeagnus, or of the glossy evergreen mahonias and viburnums – forms a delicate tapestry which reminds one of Kyoto, in its power to soothe one into a contemplative mood. This effect is enhanced by the white poplars, their chalky leaves quietly agitated by the wind. It seems to sharpen one's perception of the sculptures – the stoniness of stone, the tension of bronze.

The Moores' last acquisition, in the mid-1970s, of the neighbour's unkempt apple orchard to the right of the long walk brought new vistas into the whole scheme. When the trunks of the eccentric old trees had been cleared and two large gaps made in the hedge, one could look through a dappled space of light and shade to the sheep grazing behind a low, open fence in the meadow beyond. Here Irina has taken up the horizontal theme of pastoral peace with plantings, to the side, of horizontal junipers, potentillas and other low-growing shrubs. One looks towards this old apple orchard from the windows of the newly built Henry Moore Foundation. It is the background to the *Upright Motive* and to a *Reclining Figure* soon to be replaced by the *Seated Warrior*.

On one of our visits a single rogue sheep had jumped the low fence from the meadow and was grazing round the *Reclining Figure*. Irina's transitions between garden and meadow are so natural that he

seemed entirely at home, no more than a mildly amusing accent in the garden scene. Occasionally Irina jokes about some formal idea for the garden she had entertained but discarded. For instance, there was the short-lived but unfulfilled enthusiasm for a maze, quite an Elizabethan theme, in tune with Widford and Much Hadham architecture. Yet always in her imagination the contrived gives way to the natural, and her love of plants is always for their character, never for their rarity or popularity. Between the house and the Foundation a large hornbeam tree, a particular favourite of Henry's, is surrounded by plantings of mock orange and native honeysuckle and in the whole new Foundation garden the only 'novelty', bred nearby in Much Hadham, is a small clump of 'Red Ace' potentilla. One architectural feature, a large two-storey-high window at the entrance, seems to demand a more conscious gesture, and Irina's choice of the feathered acacia 'Frisia' reflected in its panes is entirely appropriate. But nowhere else in the garden is one aware of any conscious effect.

If one visits old friends at their home once a year, say, over a great many years – as we have done with the Moores – the sense of a space filled with memories of them, and of us, on each such occasion, tends to obliterate time. One collapses together disparate impressions as though they had all happened within a few weeks, not years. 'It all went by so quickly,' is the signature tune of the old. Inevitably, I feel this way about the Moores; inevitably this feeling reflects back on us too.

Henry and Irina Moore and his sculpture and drawings, with the Moore Foundation today in Irina's garden, are, of course, a triumphant conclusion to a triumphal life. The fact that out of all this their friends should be able to retain one single impression persisting through all the others of Irina and Henry, first at Hampstead and then later, and for far, far longer, at Hoglands, Perry Green, Much Hadham, is a triumph of another kind. Nevertheless, it is of the very essence of Henry and Irina being what they are, that success is not all. The awareness that comes through Irina's remarks is that what mattered all their lives was not the prizes and the honours – not even the results of the work, great though these were – but the work itself, the act of creating art which seems to have filled up every day of Henry's life. For Henry and Irina, existing together and his work

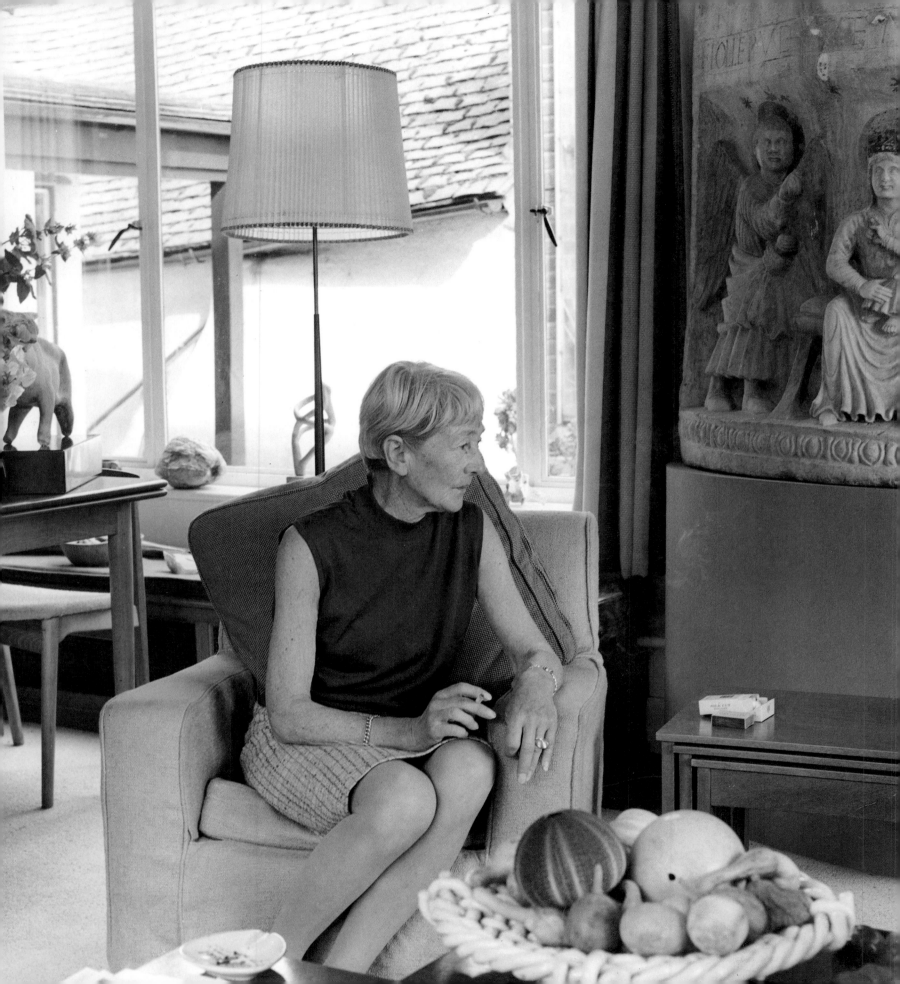

have been a single, inseparable process. When the act of working is withdrawn, the achievement becomes a monument of which the artist himself is a spectator — spectator of his own past power to have done this. My conclusion brings me back to the way in which Irina ends her remarks — noting though, their underlying irony. If Irony were the name of a flower, it would grow, I am sure, scarcely noticed perhaps, in Irina's garden. For me the words with which she ends her remarks have ironic meanings not on the surface.

> Now we are getting a little richer. It hasn't been easy all the way — rich, poor, rich, poor, that's been my life. I know always that if you have money or success, it could be gone tomorrow, so it doesn't really matter.

It was the life of work and loving invention that mattered, whether in Henry's studios or Irina's garden.

I should like to thank my wife, Natasha, who has transformed a wilderness into a marvellous garden at our own house in Provence, for her help with matters of planting and plants at Irina's garden.

Irina Moore in the New Room

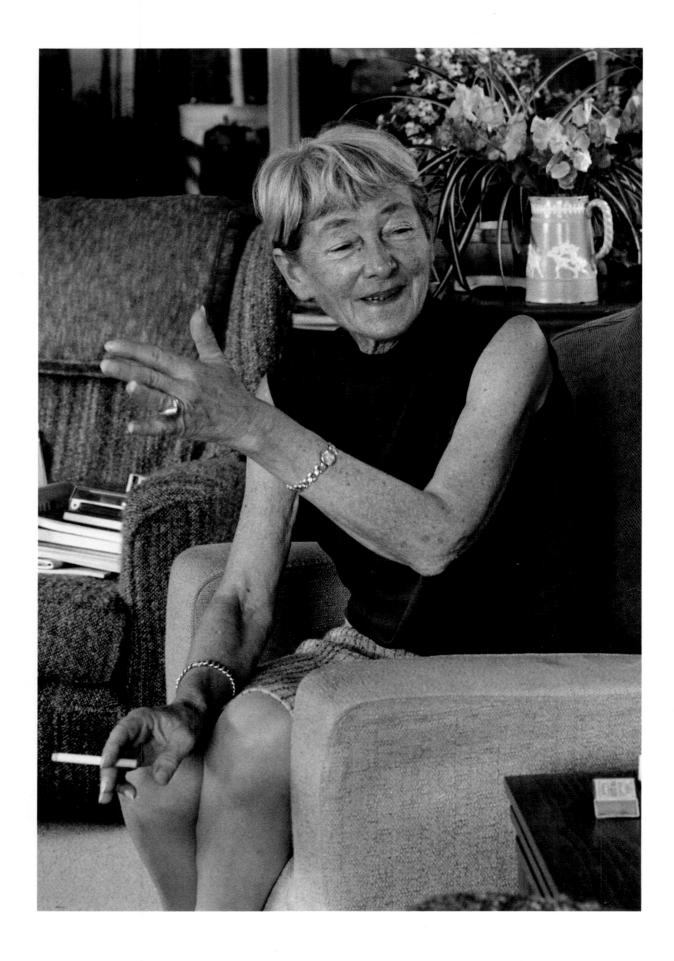

'REMINISCENCES'

by Irina Moore

We bought our house in Much Hadham during the war, in 1940. London was being bombed at the time and although we had not had a direct hit where we lived in Hampstead, bombs had fallen nearby, knocking windows and doors out. The first place we lived when we got married was 11a Parkhill Road off Haverstock Hill in Hampstead. We didn't own it, we only rented it. Barbara Hepworth and Ben Nicholson had a studio round the corner. There were a lot of studios, in fact seven or eight. Barbara and Ben went off to St Ives at the time when many people left London, so we moved into Barbara's studio and that was much larger than our old one. It had a staircase up to a balcony, a tiny kitchen and a bathroom. That's where we were bombed – not directly, but it's extraordinary what the blast from a big bomb can do. It ruined everything.

We couldn't live there any longer, so we went to stay with a friend of ours who lived in Much Hadham. We found a house called Hoglands, half of which was unoccupied and in a terrible state. We knew it was a solid old house that went back to the 1400s – or at least the original part did – and we bought it for £900. The people who lived in the other half of the house couldn't pay the mortgage and the owner didn't want them to stay. At the time Henry sold the wooden figure – the elmwood sculpture that has a lot of holes in it. He sold it for about £300 and that got us started. I don't know where the deeds are. The deeds are on parchment, you know, with seals and everything.

You wouldn't have recognized the house the way it was then, though gradually we put it back into good order. To begin with, we had only one acre of land, but I had a small garden and grew all the vegetables we needed and we had two hens supplying us with eggs.

The farmer down below had cows, sheep, pigs, birds and animals of every sort, all kept behind barbed wire. He also cultivated rhubarb and other vegetables which he used to take to market in London. When he got to be over seventy, he decided to sell us his farm.

Eventually another neighbour in Much Hadham moved away and we acquired his farm. And then there was another, and another. One had a potato field; another had a sheep meadow. We were able to buy them when they were put up for sale. Houses, with outbuildings which Henry could use for studios, became vacant. We grew more or less without doing anything, just by living here and buying what became available.

With my garden I have a vision of things: that's how I planned the walks, the hedges, the trees and flowers. I do things by instinct, and I enjoy the way they look when they are right. When they are wrong I am very cross. For instance, the wall was built too high and we couldn't see some nice peach trees that were doing very well on the other side of it. So it had to come down. We built a smaller one which is just right.

I decided to make irregular beds for the flowers and bushes, and Henry started putting sculpture there. I like to see the relationship between the sculpture and the hedges and trees, and I helped Henry to find the right places. I think sculpture looks better out of doors, but I don't like those sculpture parks so much. When they did the first Battersea Park exhibition of sculpture, that was fine, though perhaps there were too many works crowded together. When Henry shows his work outside, he must be satisfied with the site; if he doesn't think it looks right he won't show it.

I have always been a collector; I collected butterflies at one time, I still collect stamps. I collected cactus plants because I like the shapes and the unusual colours when they flower. I used to have them in Hampstead where I had little shelves built on the windows; then, when we moved to Much Hadham some years later, we built a greenhouse for them. When we bought the house which we call Gildmore I got another greenhouse, this time for orchids – they are

quite easy to grow. I also like sponges, I don't know why, but I have a passion for sponges, real sponges, natural sponges . . . it's very odd.

I don't attempt anything that's very difficult. Even the trees I have planted are ones which grow quickly – like ordinary poplars. A poplar is a very simple tree. Everything here is very . . . well . . . 'ordinary' isn't a nice name to give it. It's a *simple* tree, the usual tree, a common tree, everybody's tree. Henry has made a lot of drawings of those trees – Henry put all the laurels round the house because there was nothing there to begin with. He didn't work in the garden, he's no gardener. I don't even remember him mowing the lawn in the early days, although he says he did; but he did help me to plant things. That was many years ago when I had a lot of energy. I grew vegetables around the house at first, then I put in a lot of campanulas which are very easy to grow: you don't have to do anything with them. Some campanulas are short and have flowers, and sometimes they grow a bit taller. Those are the purple variety, dark and light purple. They seed themselves. We also have Michaelmas daisies and chrysanthemums in the winter. Down below, around the studios, we have planted other perennials.

About fifteen years after we bought the house we built onto it what we called the New Room. That's where we spend most of our time now. We wanted one large room because most of the other rooms were small. We thought about it a long time before we decided to put it here. Henry and I designed it together and Henry says it is our biggest success. It is mostly windows and we feel we are living outdoors.

I do love flowers. When I was young, my grandfather had two gardeners. I didn't know anything about gardening. Then, when I was fifteen or sixteen, my grandfather gave me a small piece of land no bigger than half our living room. And I hated it. I couldn't bear it. But because he had given it to me and he was very nice to me, I had to grow something. I think I grew such things as pansies and daisies and I began to like it after a while.

Anybody can have a garden like ours. You don't have to have a lot of money. There are many charming small gardens that have been made for almost nothing. If people want to make attractive gardens, they can.

I was born in Russia, in Kiev, on the 26th of March, 1907. I left Russia when I was twelve or thirteen. My mother and I stayed in Paris for two or three years, and I went to a French school. Then we came to England and lived with my grandfather.

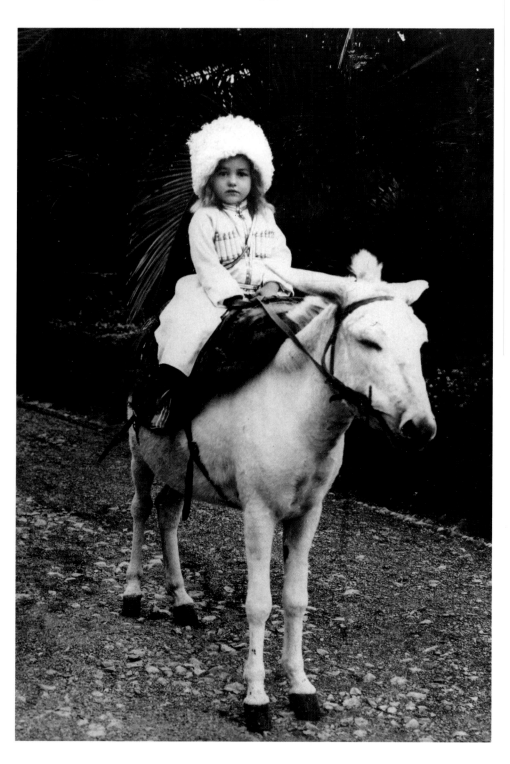

Irina Radetsky at six years old on a family holiday in the Caucasus in 1913 or 1914 (Henry Moore Foundation Archives)

Actually, he was not my real grandfather. His name was Paul Francis, and he was my step-grandfather. My mother was married several times and eventually married one of his sons, but she was always having a good time and later still she married an Englishman. I was her only child and she parked me with the father of her new husband, who became my grandfather. He was a rich gentleman living in the country; he was a chemist and one of the top partners of a large company. I remember we used to go with Grandmother and Grandfather to dances arranged for the staff. It was very Victorian, and my grandmother and other women used to put on their jewellery. Quite unreal! Then my grandfather lost all his money and we were much poorer.

My grandfather had two sons, one of whom married my mother, and a daughter, Aunt Muriel, who married a solicitor. It was the solicitor who was somehow responsible for my grandfather losing all his money towards the end of his life. Anyway, there was very little left.

When I lived in Marlow with my grandfather, I went to study painting at the Royal College of Art. I would take the train to Paddington Station and then walk across Hyde Park to the college. That's where I met Henry. He was a teacher, though not in the painting school. The sculpture school was some way away and was housed in temporary buildings. One of these buildings was used as a student common room and as the student canteen. Lunch could be had there for ninepence: you could have a wonderful lunch for very little money.

At the end of every college term there was a dance which was held in the common room. One year Henry was there and asked me for a dance. While we danced, he asked me where I lived, and so on. The usual questions, just making conversation. And then I said I had to go back to where I'd been sitting, and I sat down and he sat down. Then he asked, 'May I have the next dance?'; and I said yes. So when the interval was over he came back for me three or four times. He didn't know that the young man sitting next to me wasn't a college student; I was engaged to him. During the week I stayed in London and then at weekends – Friday night until Monday morning – I used to go back to Marlow to stay with my grandfather. The college is very near South Kensington Station, so Henry asked me at the end of

the dance if he could see me down to the station and he waited for me until I came out. The young man I had been sitting next to was there as well. Henry saw me walk out, but he didn't know who the young man was. Leslie was his name and he was terribly nice, but Henry was very pushy. Leslie was walking in the gutter and Henry was walking on the pavement with me. He took my address and told me he would write to me in the holidays. He wrote me two or three letters, and he was very good at that. He began with 'dear so and so', and then his next letter with 'my dear', and on the next one he put 'dearest'. The first letter he ended 'with my best wishes', and then 'with love', and then 'with love and kisses'. By the time the holidays were over we were thick. He used to ring me from London, because I didn't write. The trouble with me is I don't write letters. I can't bear it. I don't mind telephoning, but I can't bear writing at all.

Around that time my grandmother died. She had cancer. They lived in a very old-fashioned house, where they had rooms for the cook, the maids and a nurse, and yet when Granny died, Grandfather wouldn't let anyone do anything for him except me. I had to do everything at the age of seventeen.

Anyhow, Henry was invited down to Grandfather's which was about thirty miles outside London. He could see my grandfather was looking him over, trying to decide whether he was decent enough to let me marry him. My grandfather gave us his permission and we were married in 1929.

At the time Henry was earning some money teaching two days a week. He was paid about eighty pounds a year and the rent of the studio was also about eighty pounds, but he was selling a few drawings here and there for five or ten pounds. That's how we managed to live.

I stopped painting when we got married. You can't paint if you are looking after somebody like Henry. He encouraged me to paint, but I couldn't. He was a sculptor and I thought he was not bad. I used to clean, wash, cook, pose and polish the sculpture; I even learned how to move the sculpture. From our studio down below we had a staircase to the upper floor. We used to put a rope round the banisters, and in that way we were able to move the sculpture more easily. And then we put rollers underneath the stands. It is surprising what you can do when you want to.

When we lived in London we were very busy seeing people, dining out, having people in, and Henry working and all that. When we moved to Much Hadham, I used to spend all my time in the garden. When you live in the country you do what country people do. I have become a sort of country girl, and I love it. I haven't been able to go into the garden lately because I haven't been very well, and I miss it terribly.

I like to feed the birds. We have feeders we can see through the windows. Many farmers in England have done great damage pulling down the hedges and this destroys the birds just to gain a bit of extra ground. They are killing butterflies as well. I think it is an absolute menace. So I like to feed the birds. We used to have a bird house on an ash tree that died; we liked the stump, so we kept it as a bird feeder. The birds don't like it so much, and now we put the coconut feeders near the house and put fat in them. The birds love it and Henry likes to watch them through the windows. Henry made the bird-feeder sculpture, cast in terracotta, in front of the house after we visited Greece.

We had a wonderful time in Greece. The British Ambassador in Athens was a friend of ours and he took us around. We saw the mainland, not the islands. In the museums you could see that when people died in those early times in Greece, dishes of food were put in their coffins, or near them, when they were buried, and I think that the birdbaths had something to do with it. Another thing Henry brought back from Greece was drapery on sculpture. He didn't have drapery on his sculpture before.

We have one child, Mary, who was born after the war. When she was young she had a lot of friends and she wasn't in the garden much. She went to a very nice girls' school in southern England. Then she went to St Anne's at Oxford, which she enjoyed. I don't think she ever became especially interested in gardening, but she liked to draw and did one or two little books.

Henry has always enjoyed the gardens we've had and liked putting his sculpture outside, especially when he began to do big sculpture. When there was a chance to put sculpture in the landscape in Much Hadham, that was very important. He had begun thinking about it before we moved here, when we had a summer cottage down in

Kent. Actually, we had two places in Kent, one at Barfreston near Dover and one at Kingston near Canterbury. When we were near Canterbury, Bernard Meadows stayed with us as Henry's first assistant. We owned about four acres of land, and I kept chickens and turkeys and ducks, and I had a vegetable garden. Henry and Bernard were full of energy and worked long hours; they would throw buckets of water over each other to wake themselves in the mornings, they were so tired. I think Bernard was only about twenty when he came to us. Henry began to do sculpture that could go outdoors while we were there.

When we were in Italy we had a friend, Arturo Cavarre, who was a naive painter. He had a tiny cottage in Forte dei Marmi. It was in a part of Forte that wasn't so expensive. His wife was unwell and the doctor advised them to go somewhere warmer. I don't know how we got to know him, but he told Henry he wanted to move and we bought the cottage from him for eighty pounds. Since we used to go there every summer Henry needed a small studio to work in, so we used the original building as a studio and built a separate building to live in, with a connecting passage between them. It turned out beautifully. There is quite a nice garden there, too. We put in pineta, domestic pineta, which turned out to be those enormous pine trees that grow and grow. They were only five feet high when we planted them.

We were in Italy the year Henry had his exhibition in Florence; that was 1972. The exhibition was open all summer and we stayed there until October, or maybe later. It was very cold by that time and we had to buy large electric heaters because we were freezing. The marble floors in Italy are good for the summer but not for the winter. We didn't have a fence round the house, only a very small hedge, and our heaters were stolen. Another time drawings were taken. Now we have bars on the windows and bars on the door; you have to lock everything. I think it's terrible to have to live that way.

I don't like the excitement of exhibitions, though when I was young I got used to it. In the beginning it was necessary for me to go to openings, but I don't think it ever went to my head. I didn't like it, but I knew it was necessary: without exhibitions how could anybody know about you? If nobody knows about you, you can't sell anything.

We had some friends whose husbands were quite gifted; the wives were so overjoyed and overpraising that I don't think they helped their husbands very much – they spoiled them. I never did that with Henry. It's a funny thing – I don't know whether it's got something to do with my background. In Russia we were very rich, then in the Revolution we lost everything. It was really terrifying: I lived through that for three years – three years of near starvation. And then my mother got involved with the Francis family and we were rich again. They lost all their money and I married Henry who was poor. Now we are getting a little richer. It hasn't been even all the way – rich, poor, rich, poor, that's been my life. I know always that if you have money or success, it could be gone tomorrow, so it doesn't really matter.

TREES IN THE GARDEN

Drawings by Henry Moore

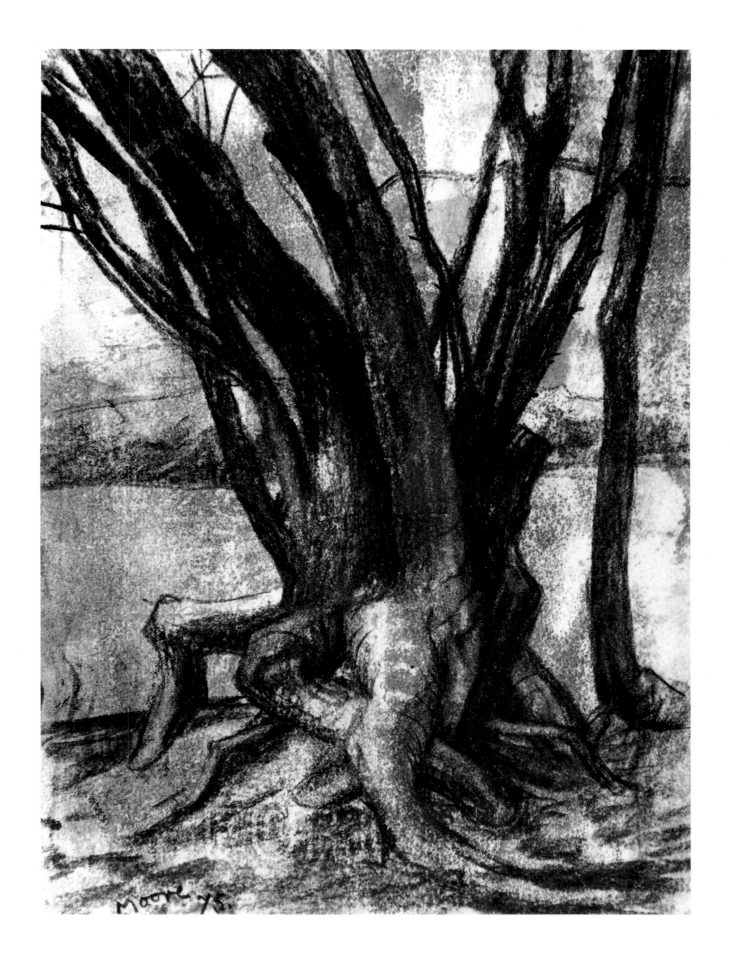

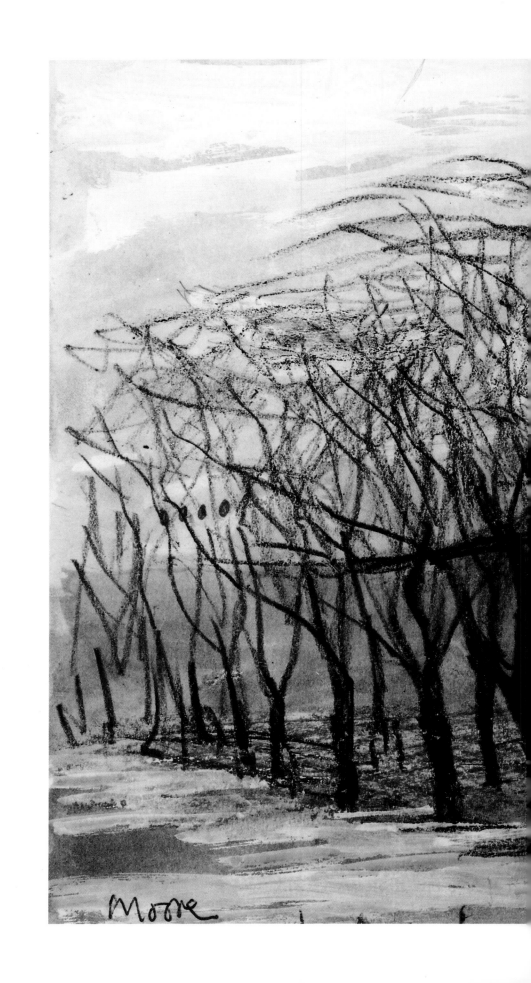

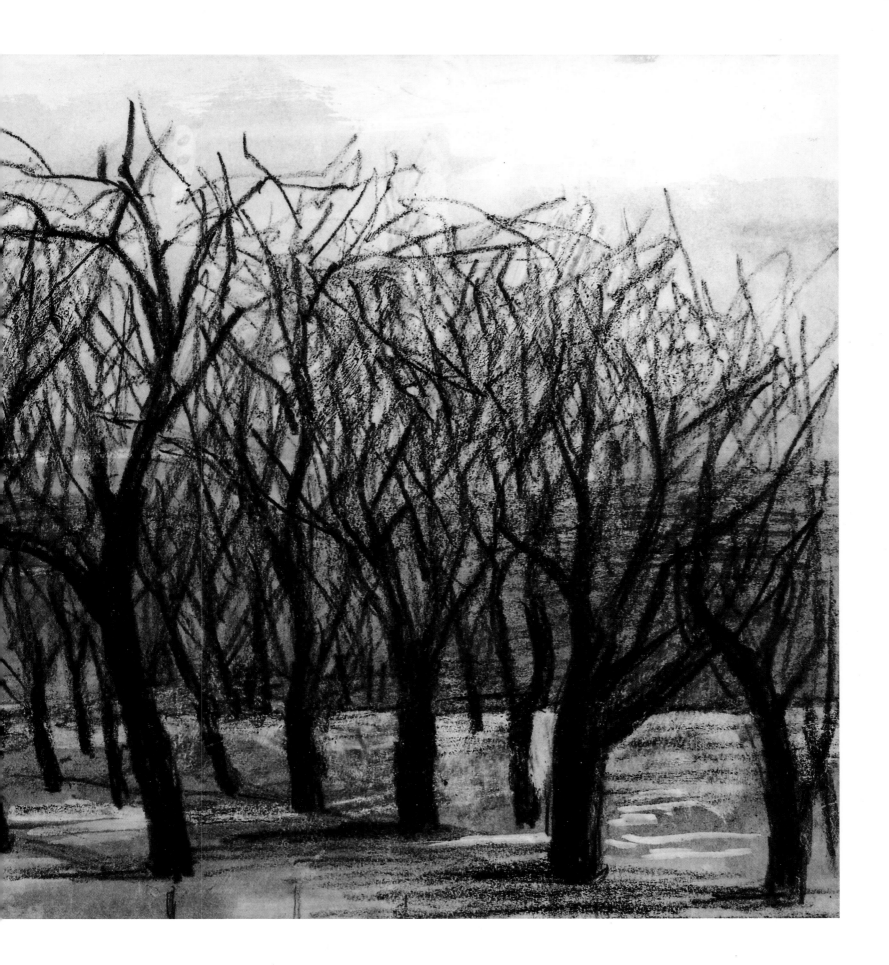

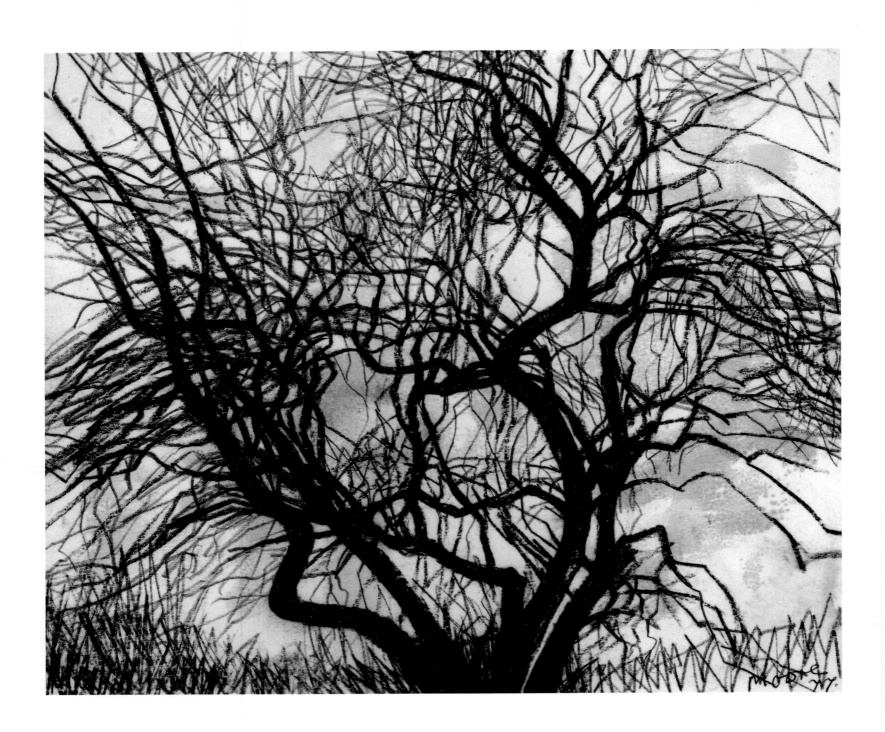

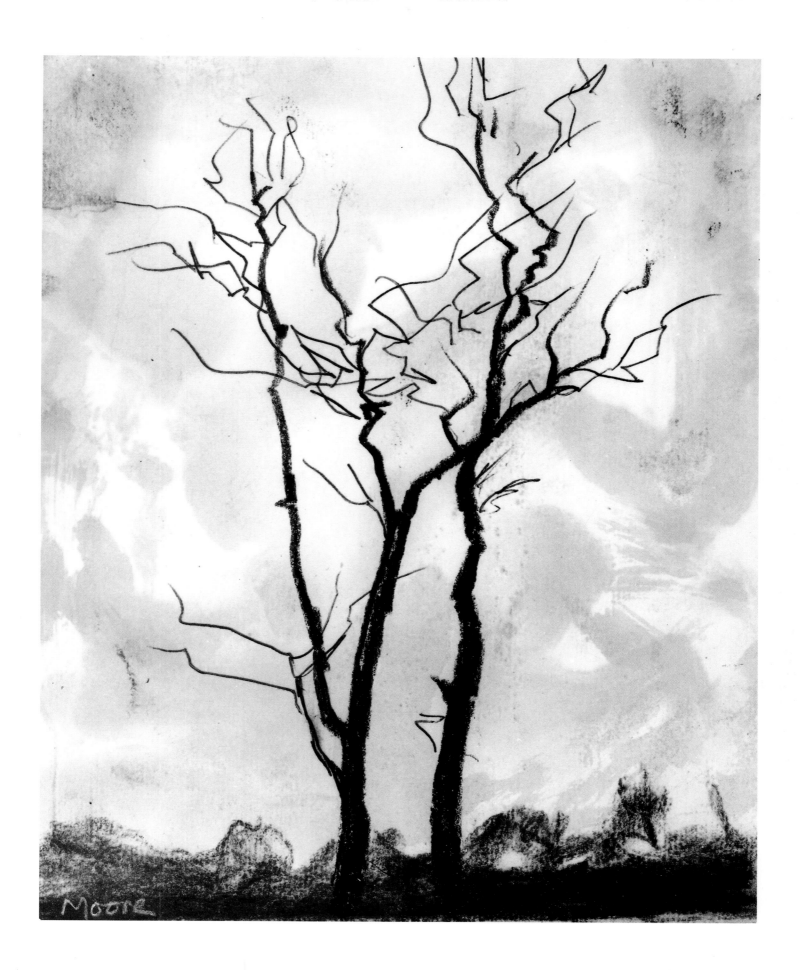

SCULPTURE IN THE GARDEN

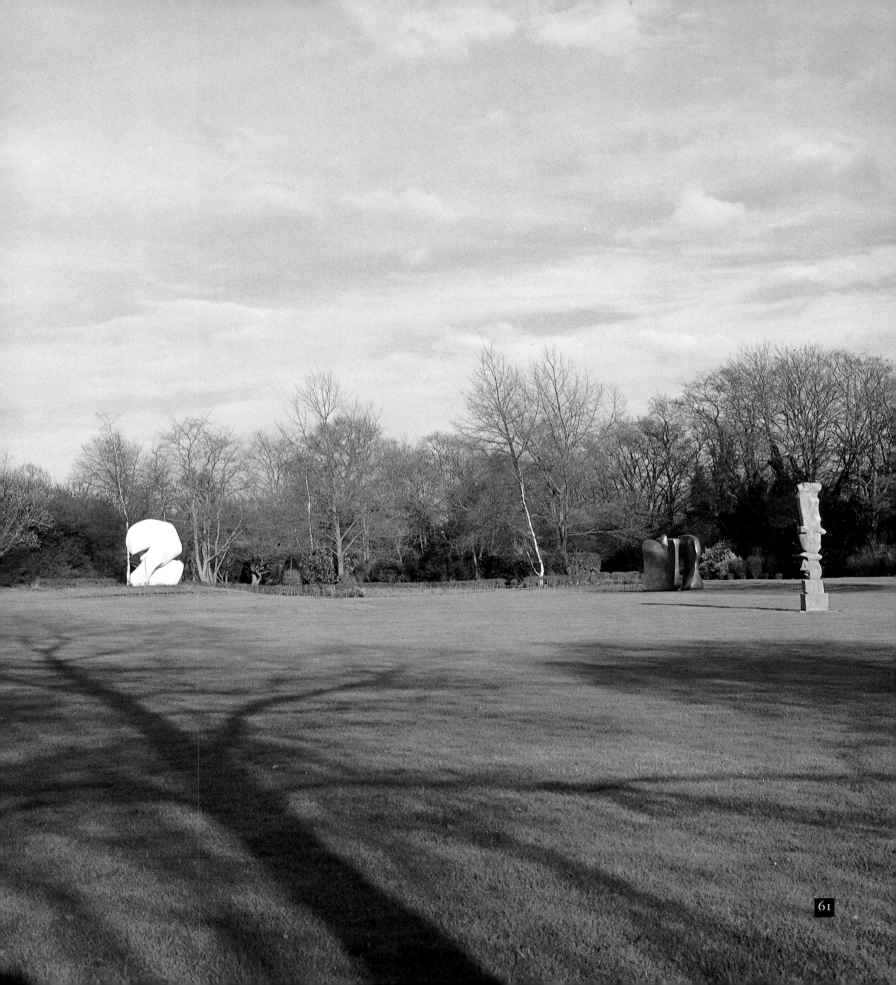

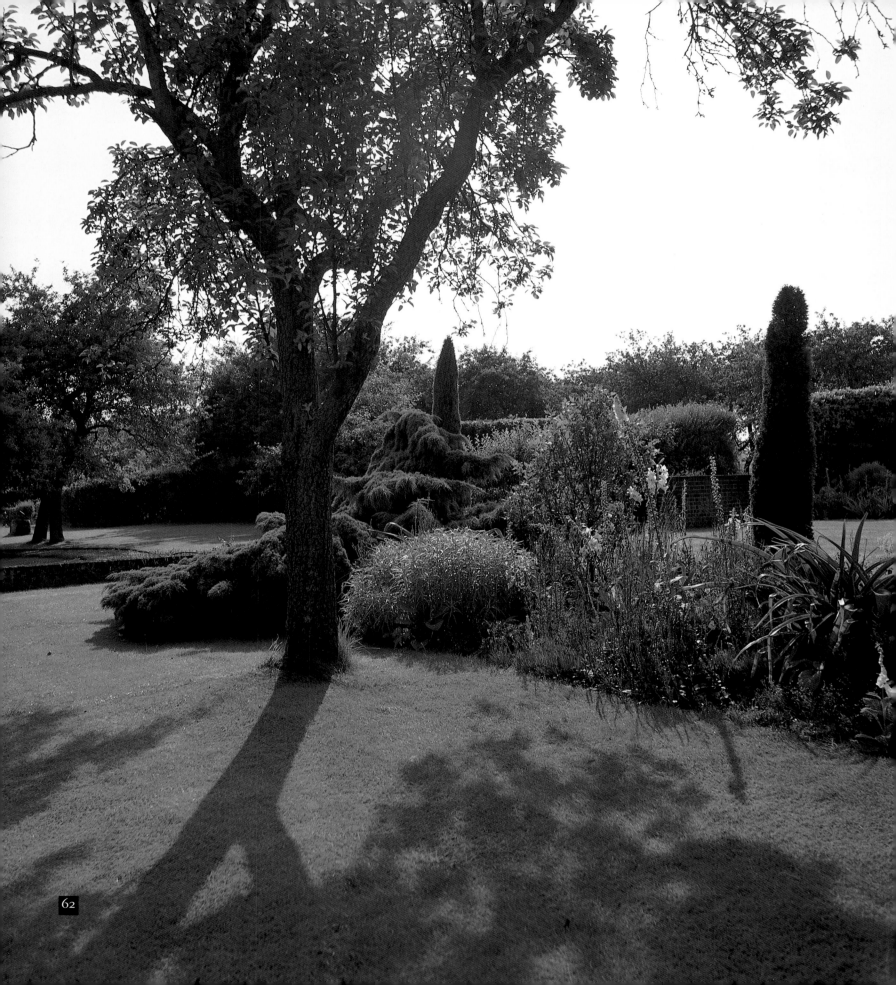

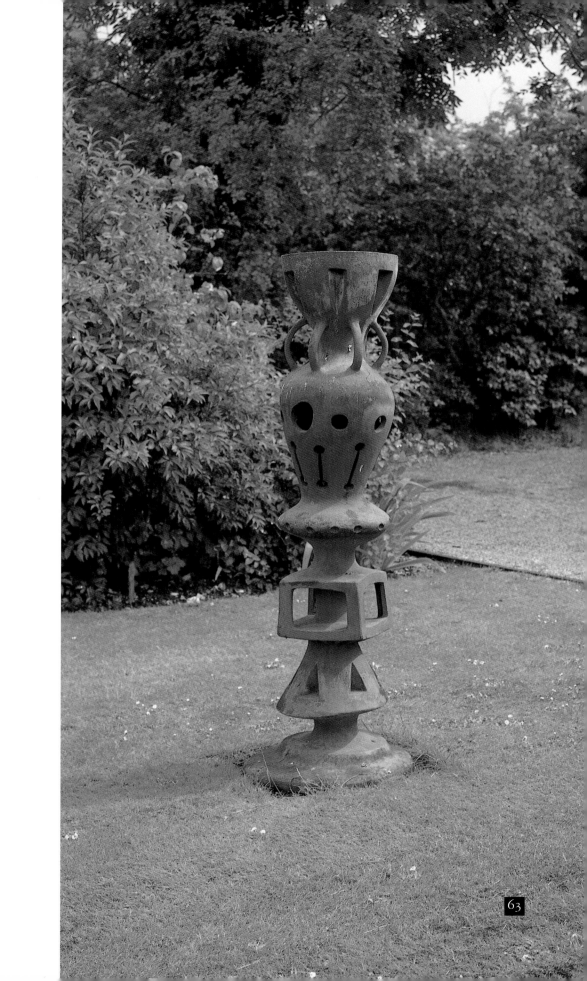

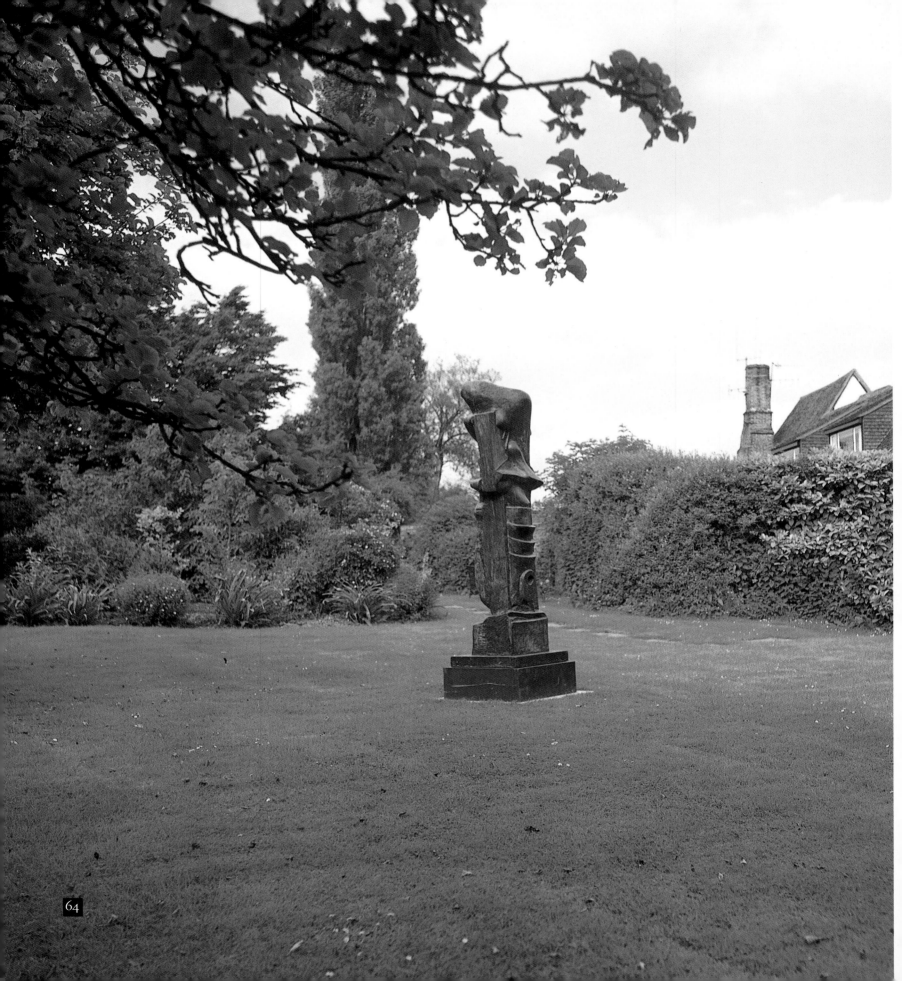

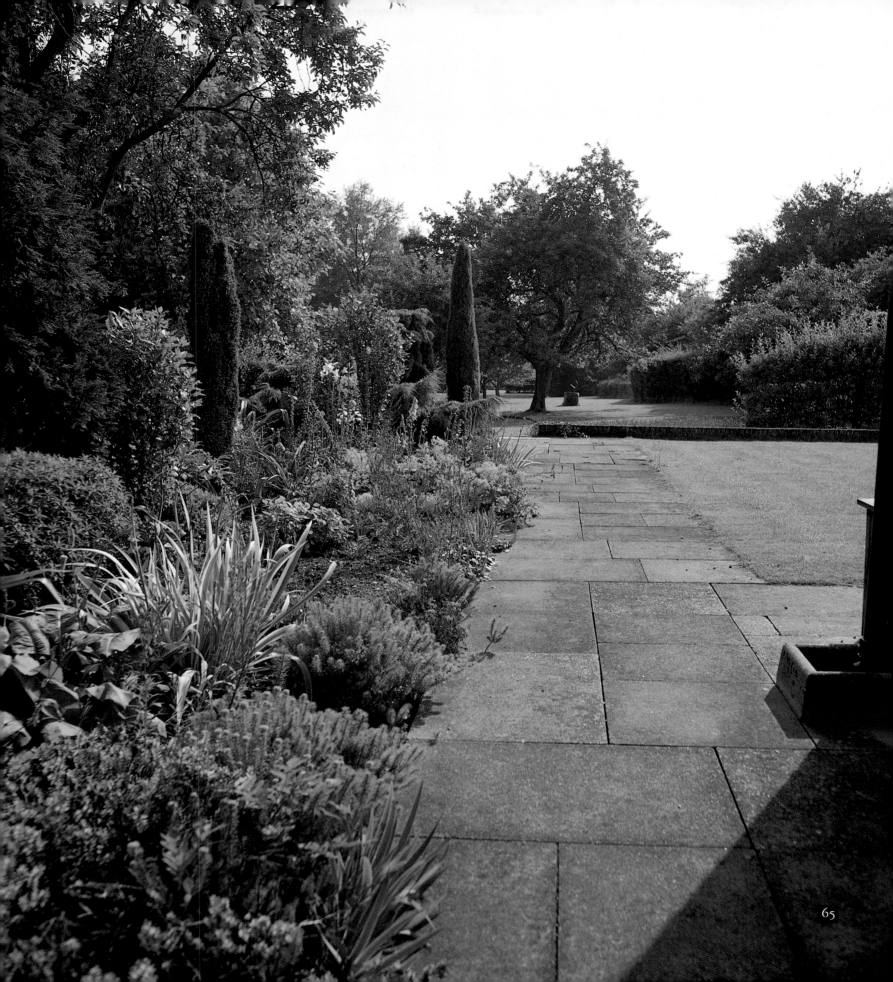

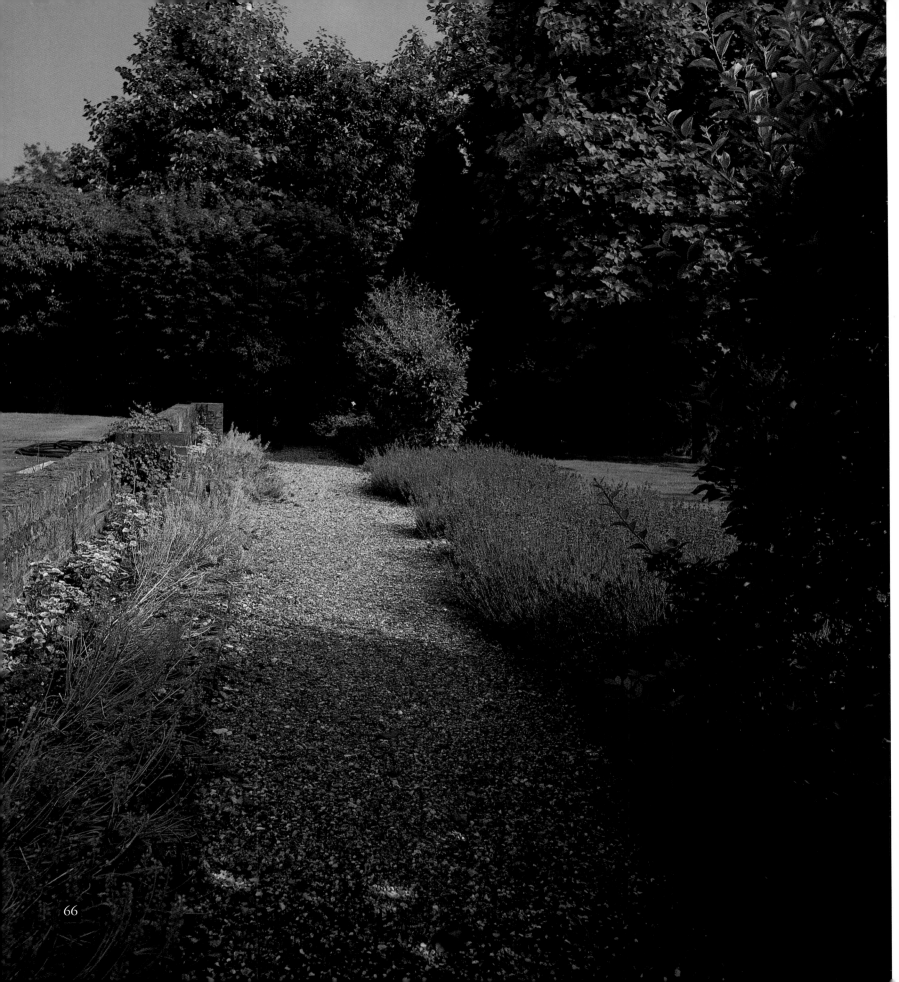

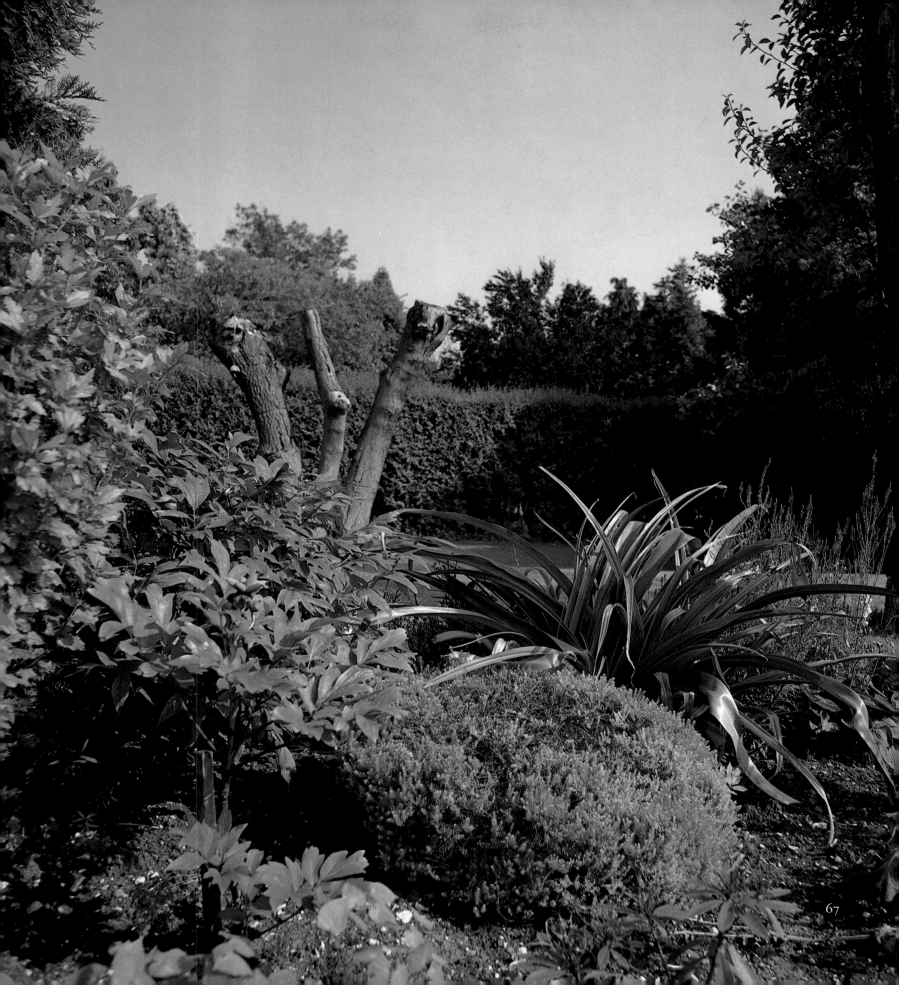

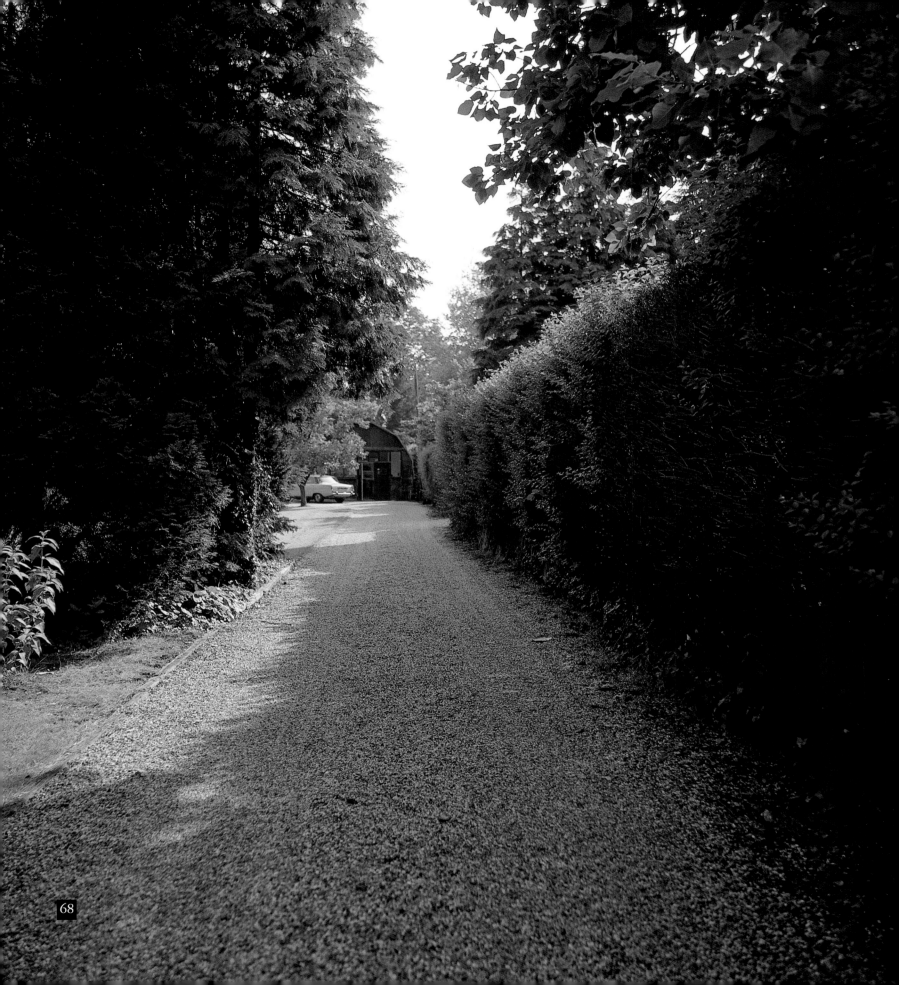

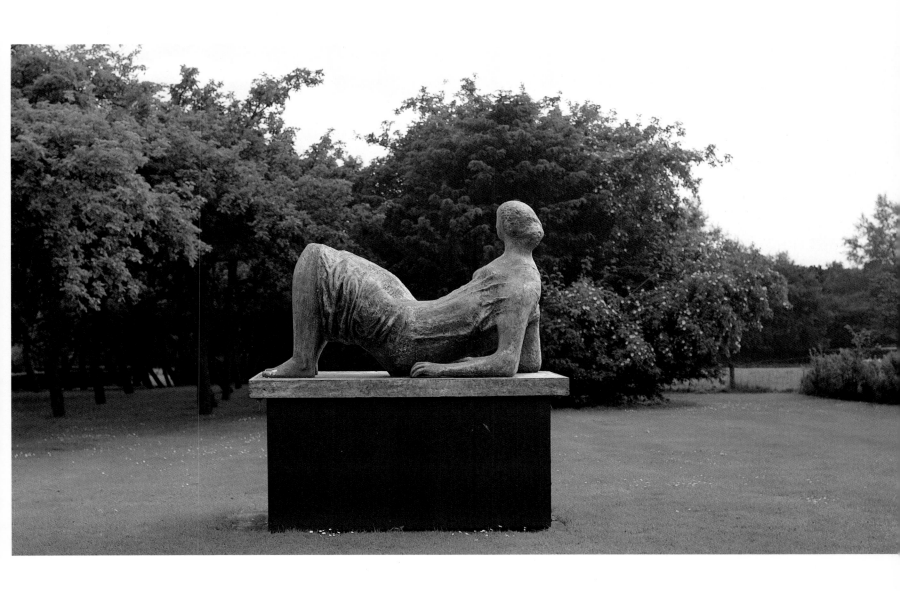

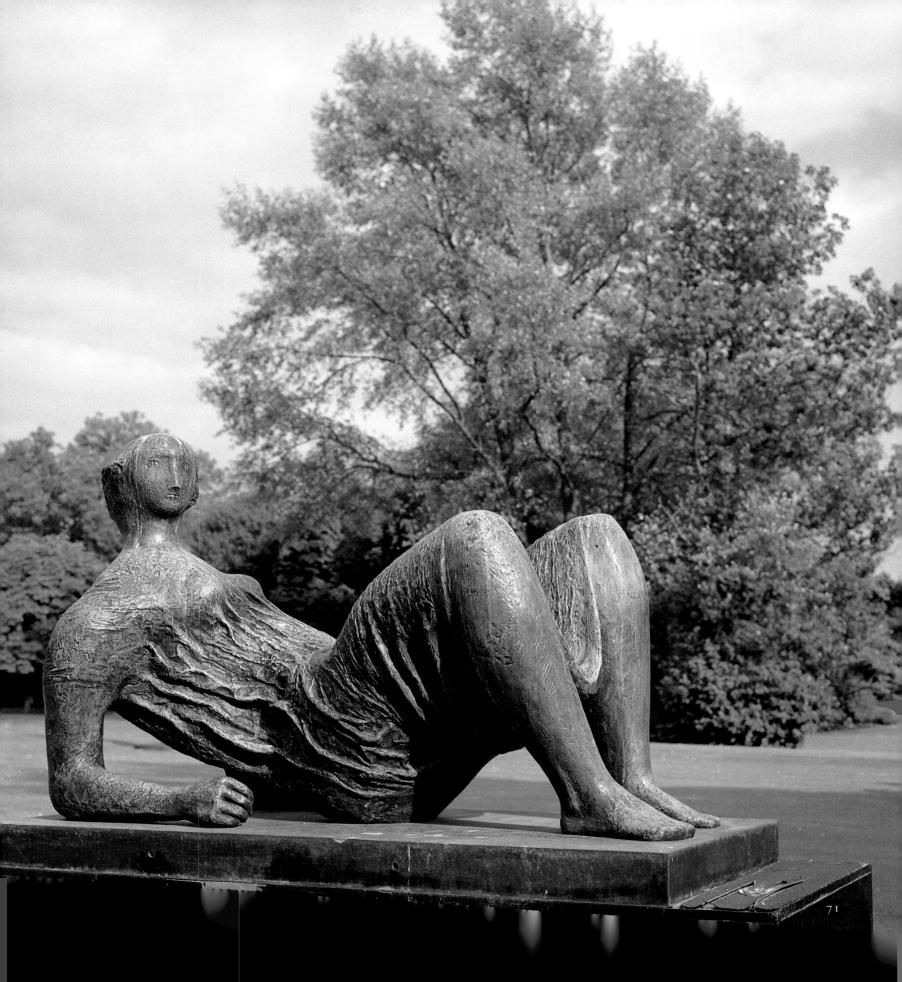

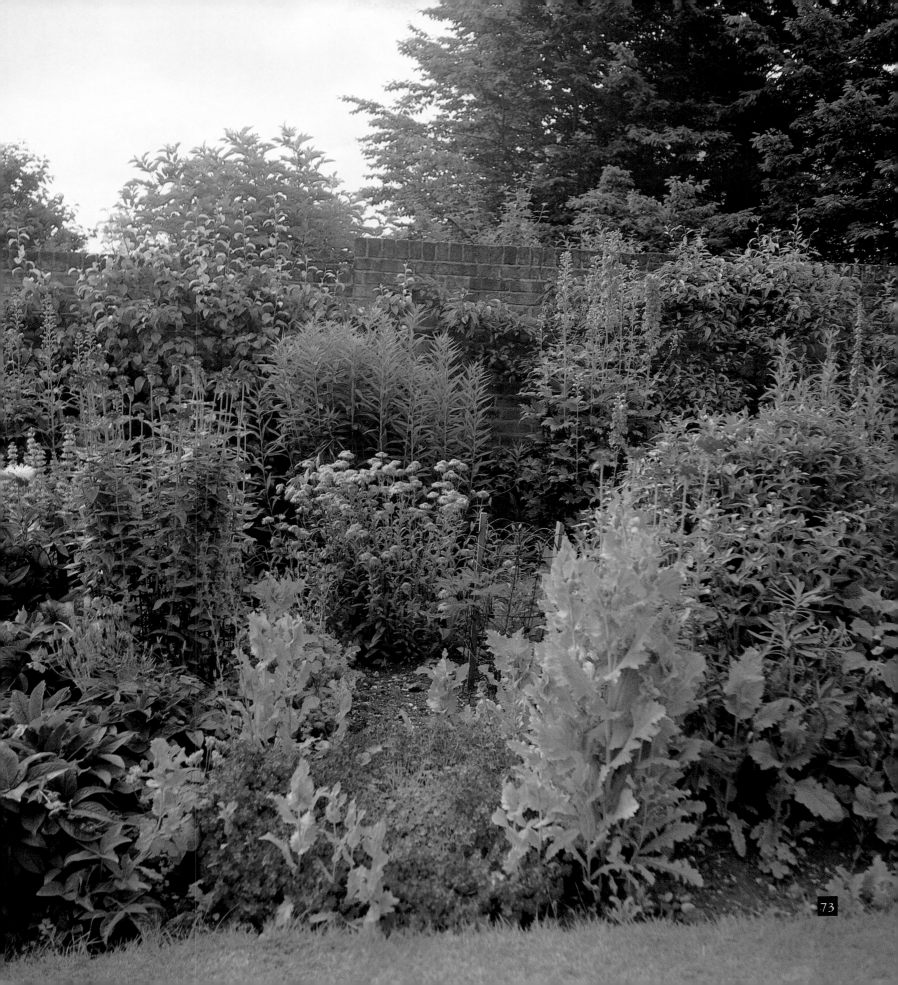

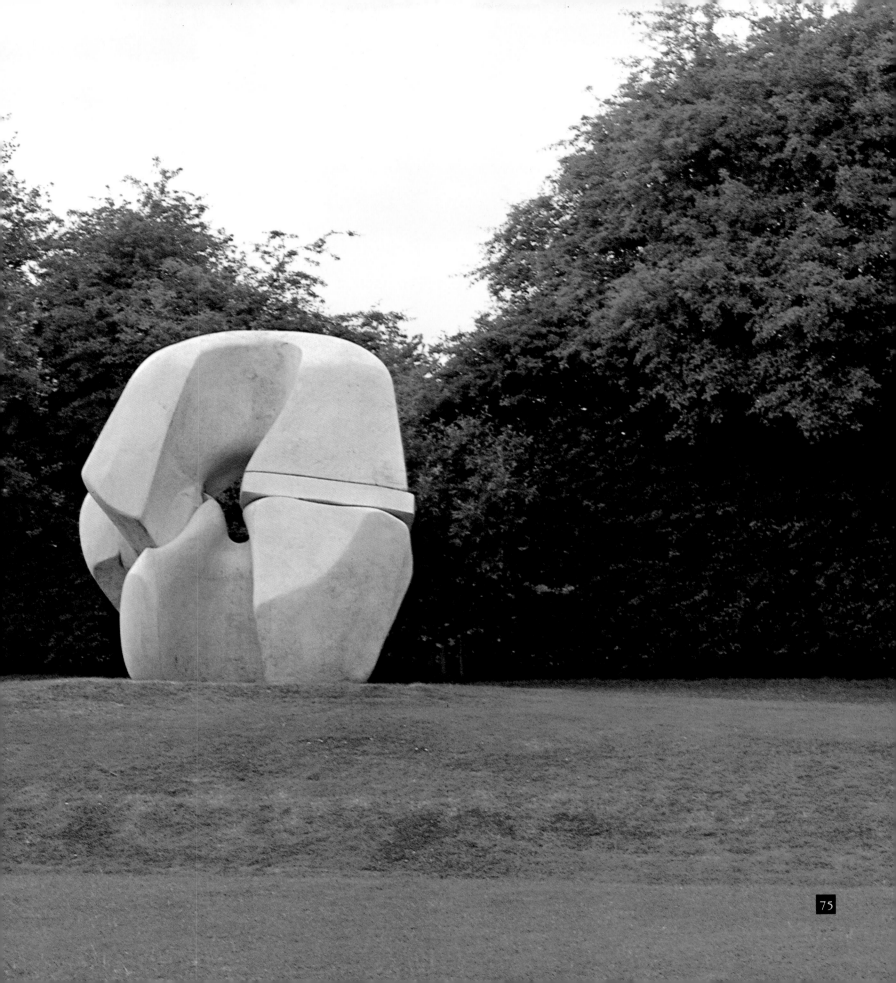

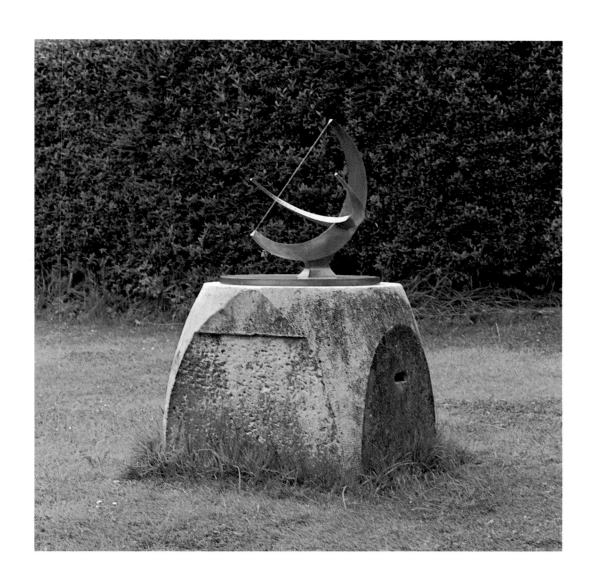

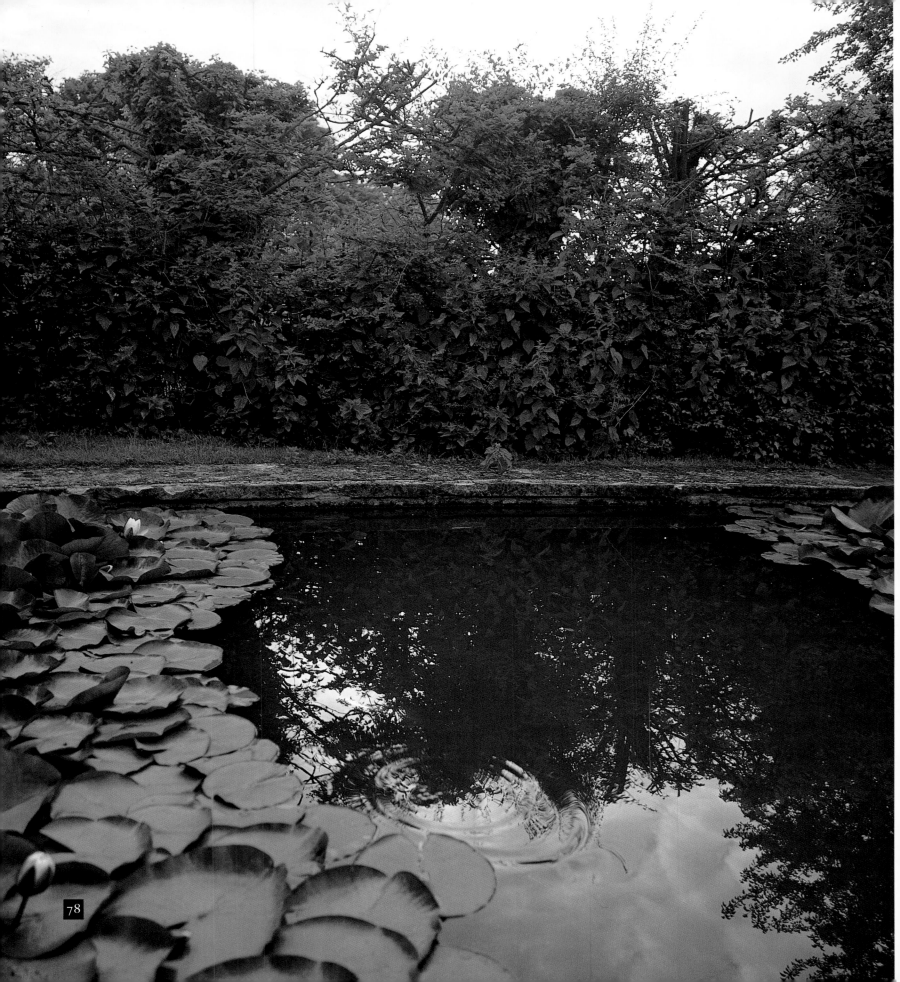

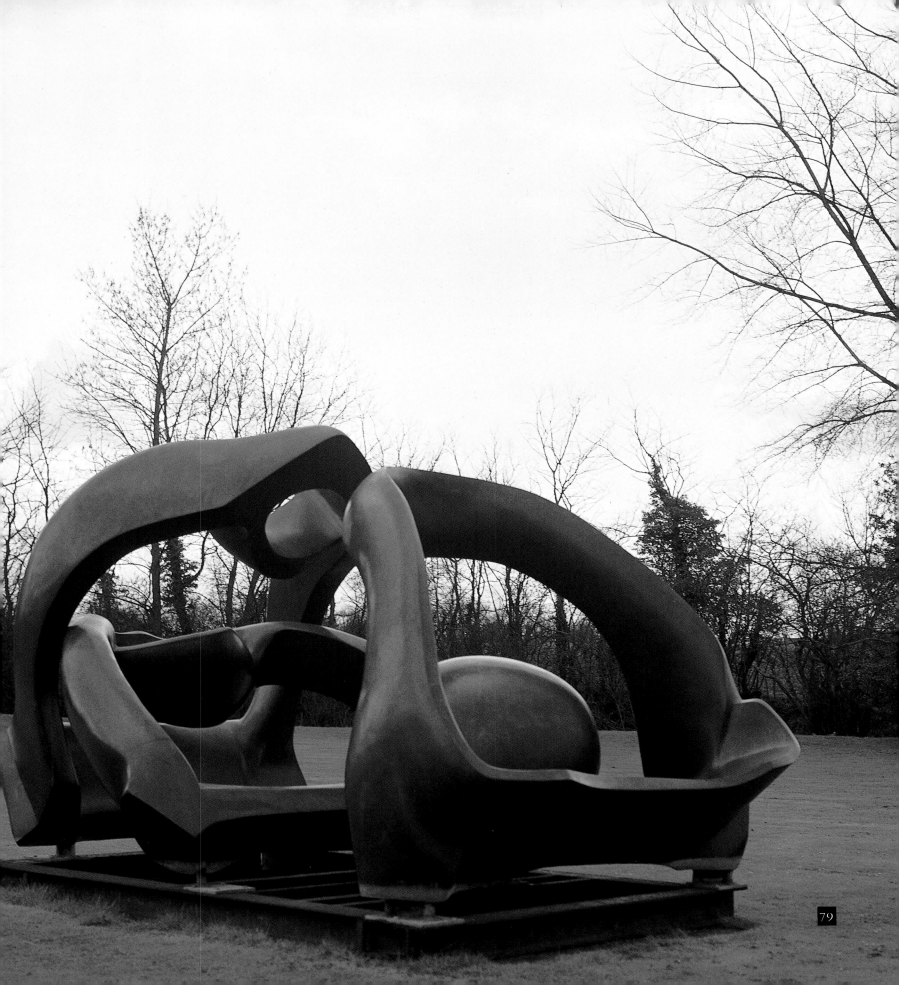

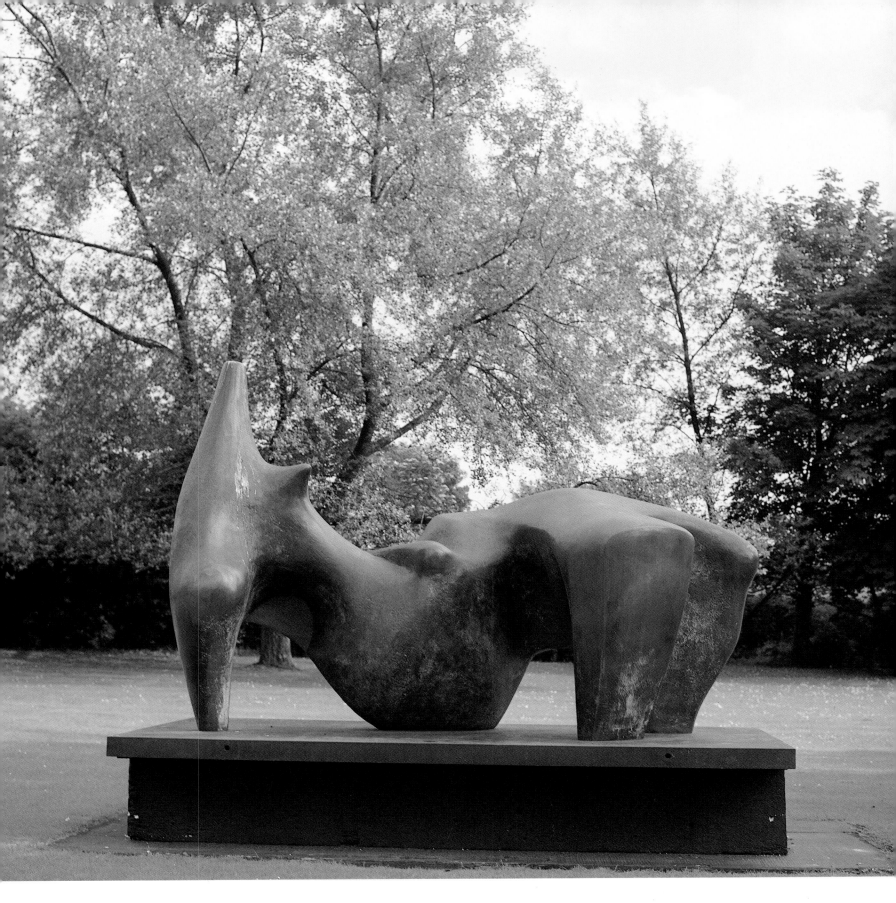

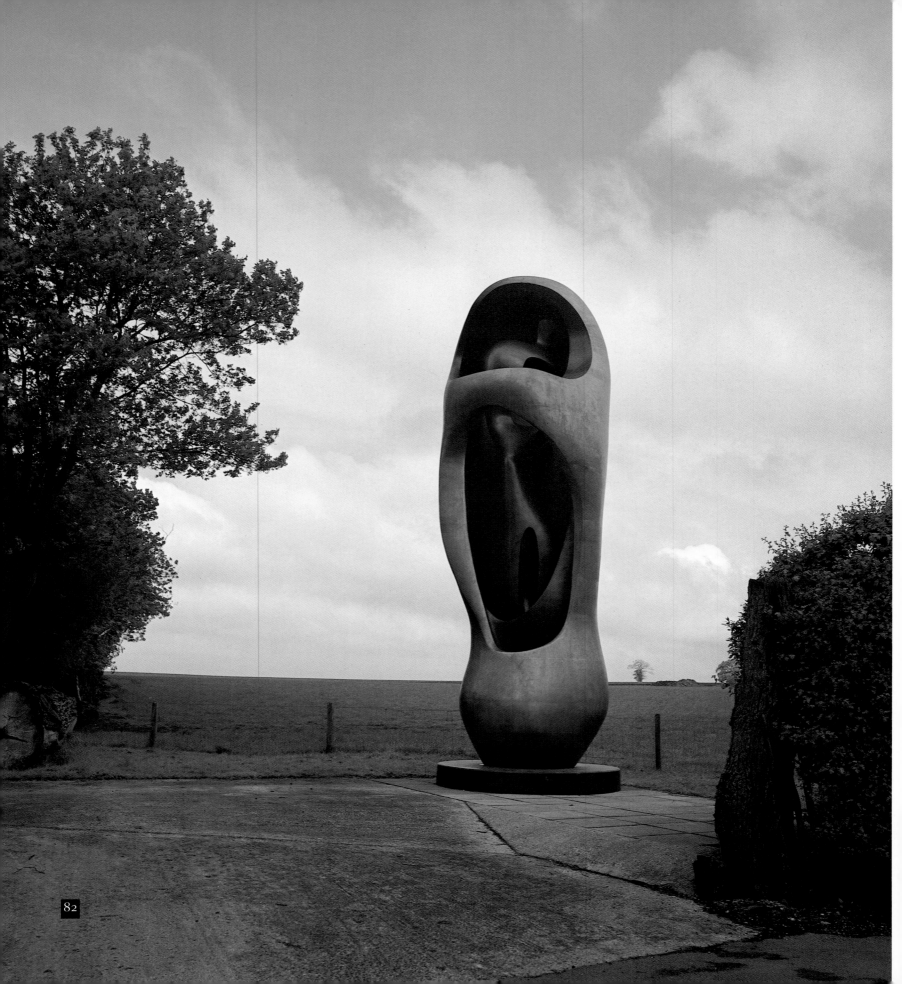

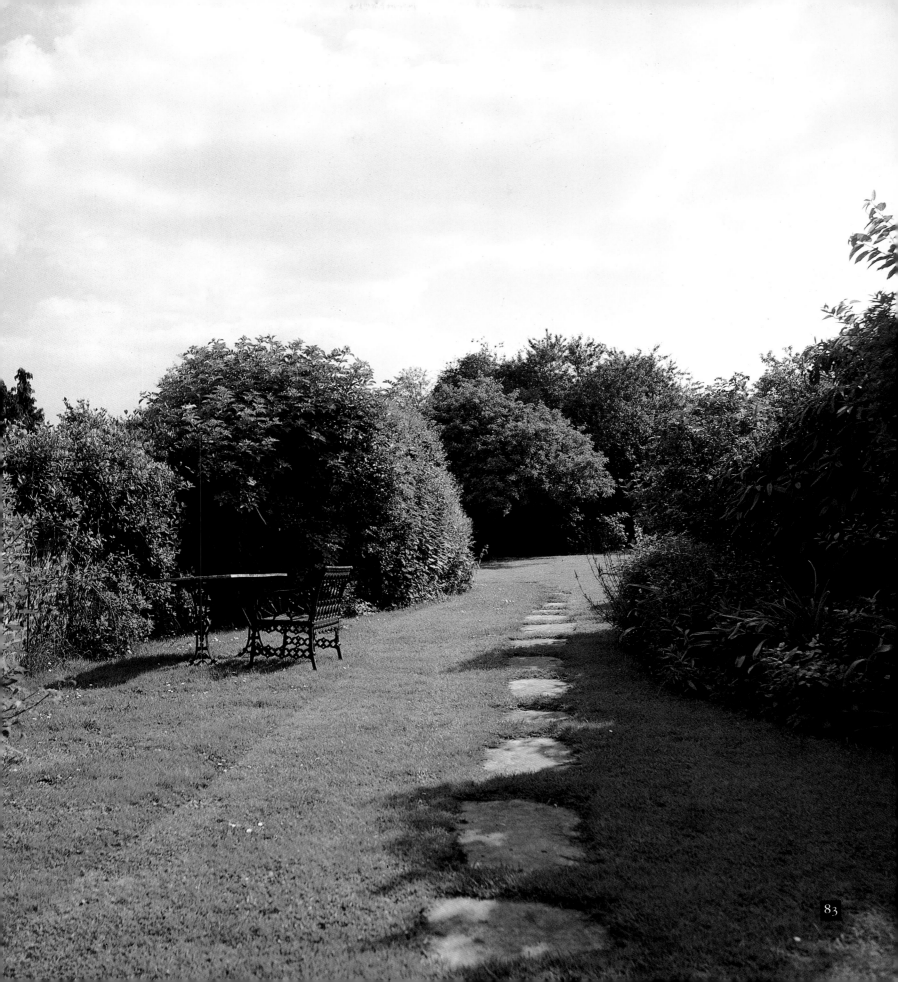

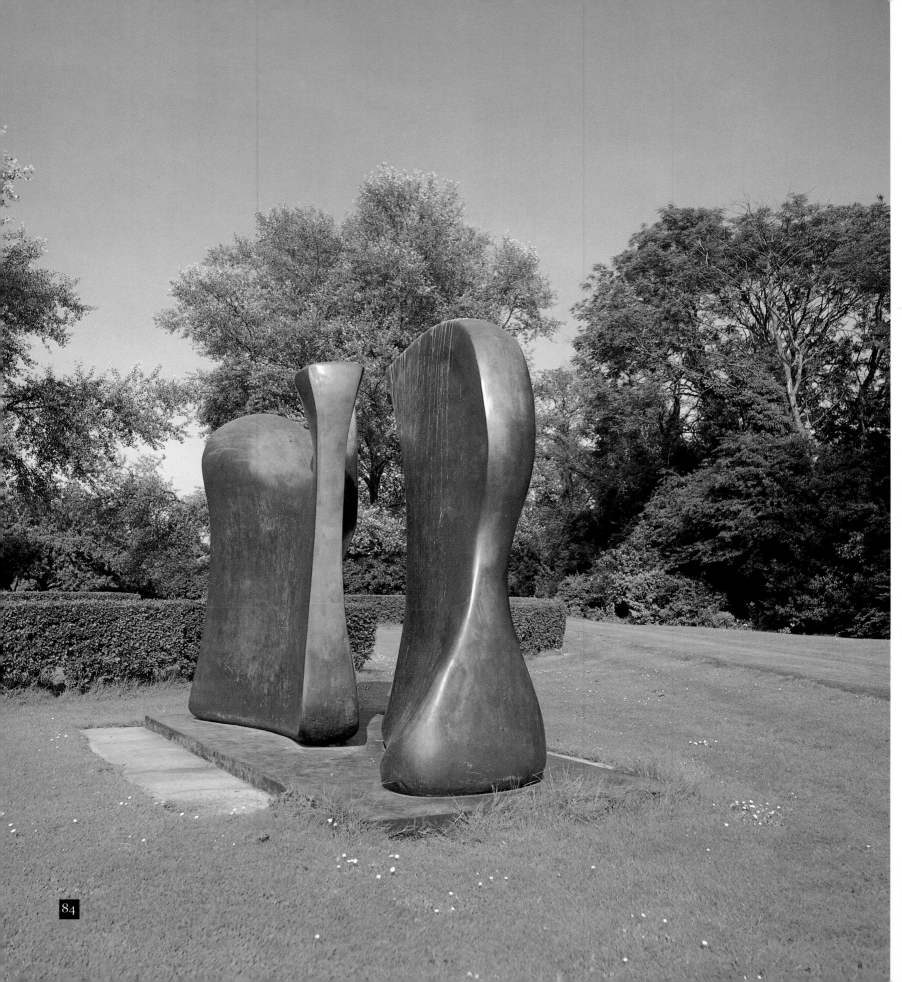

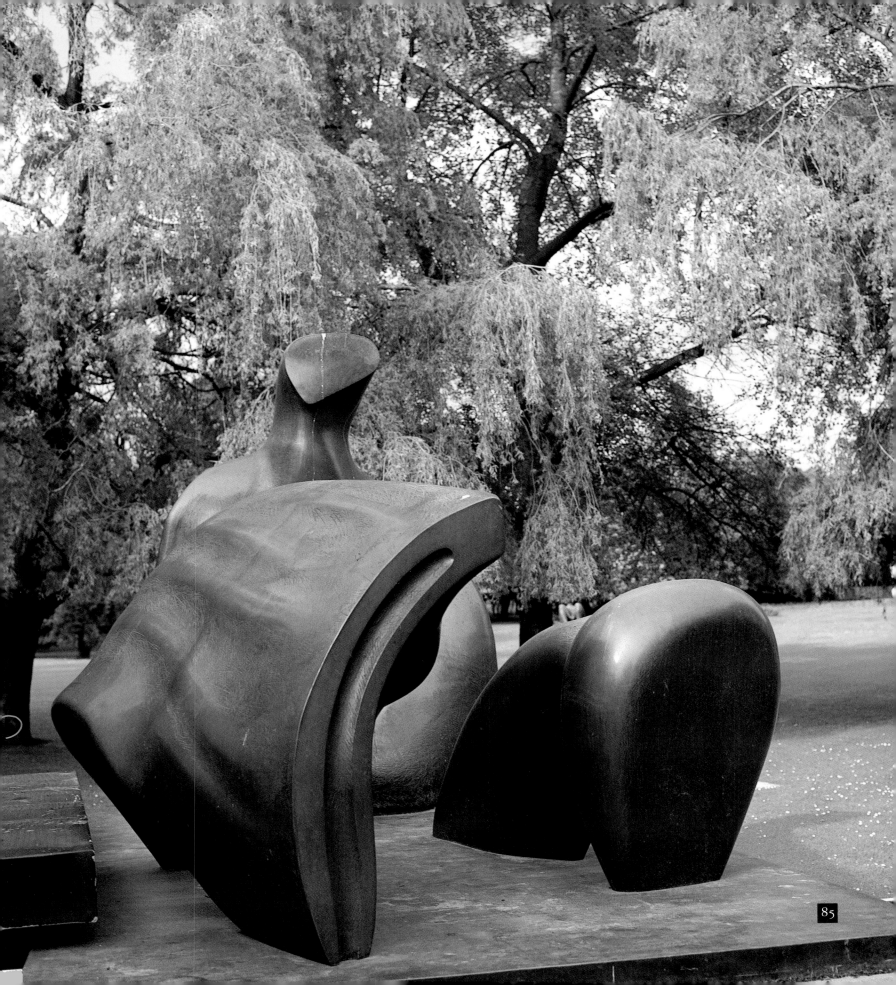

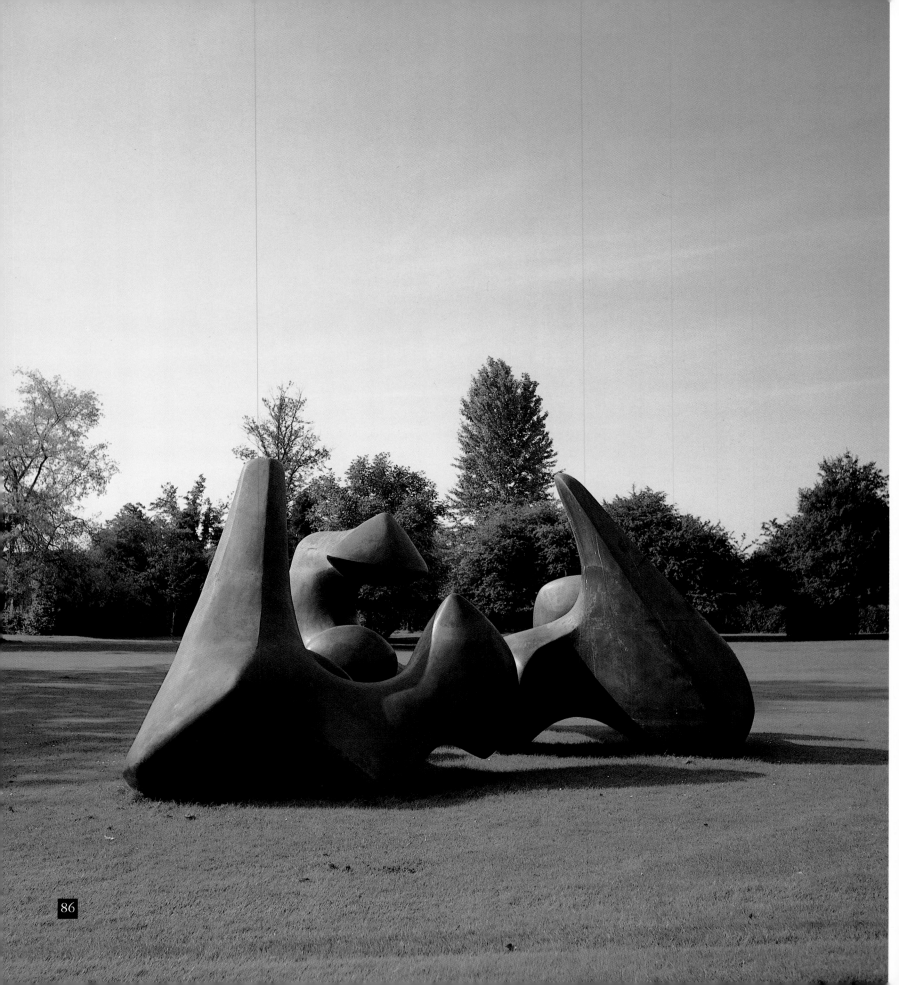

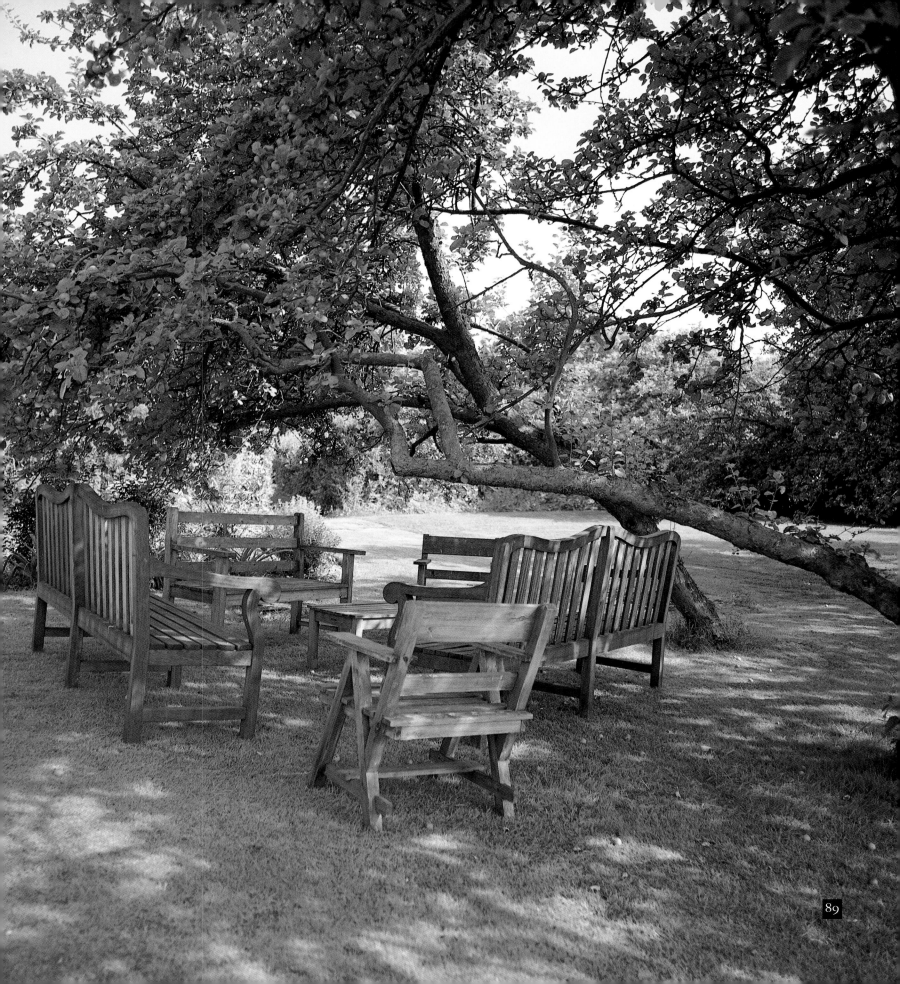

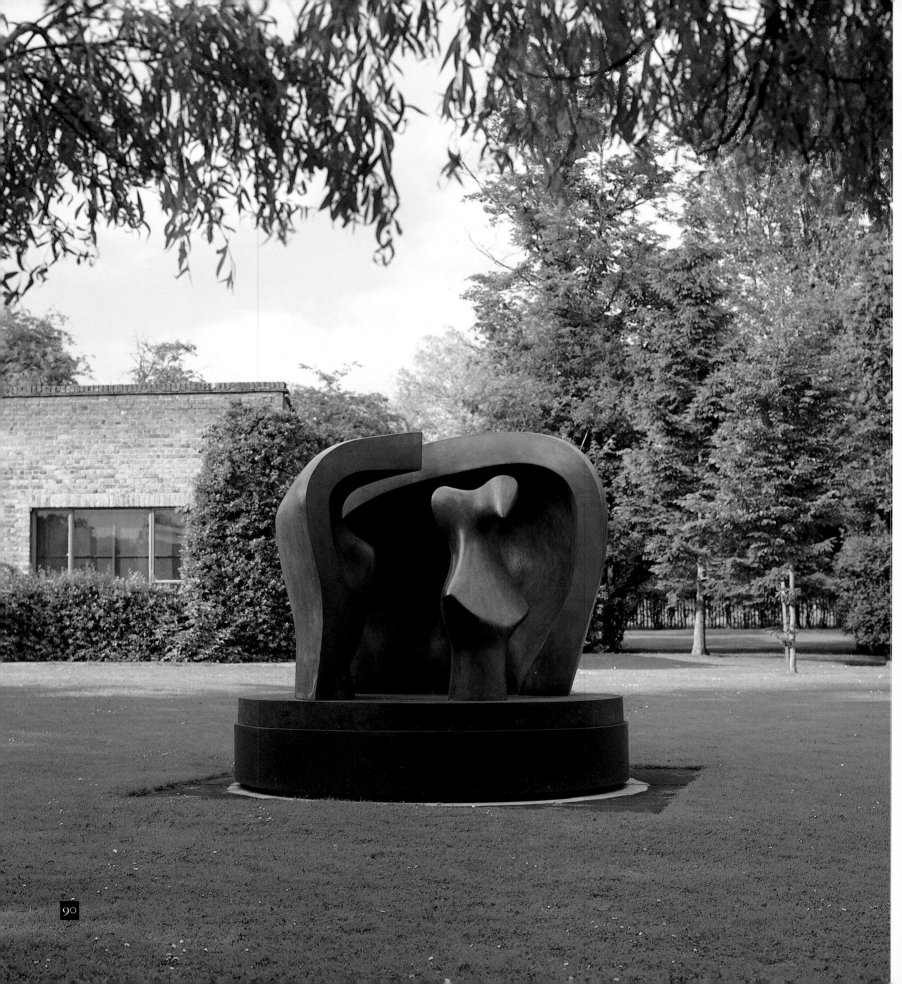

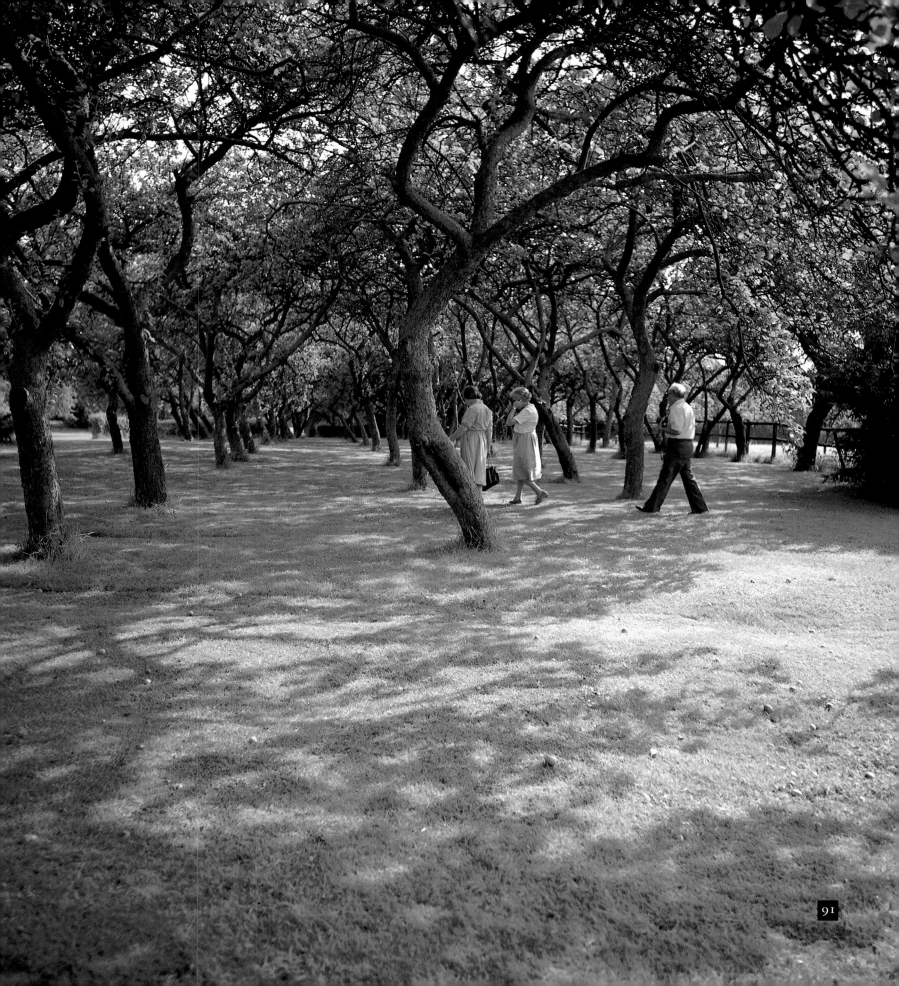

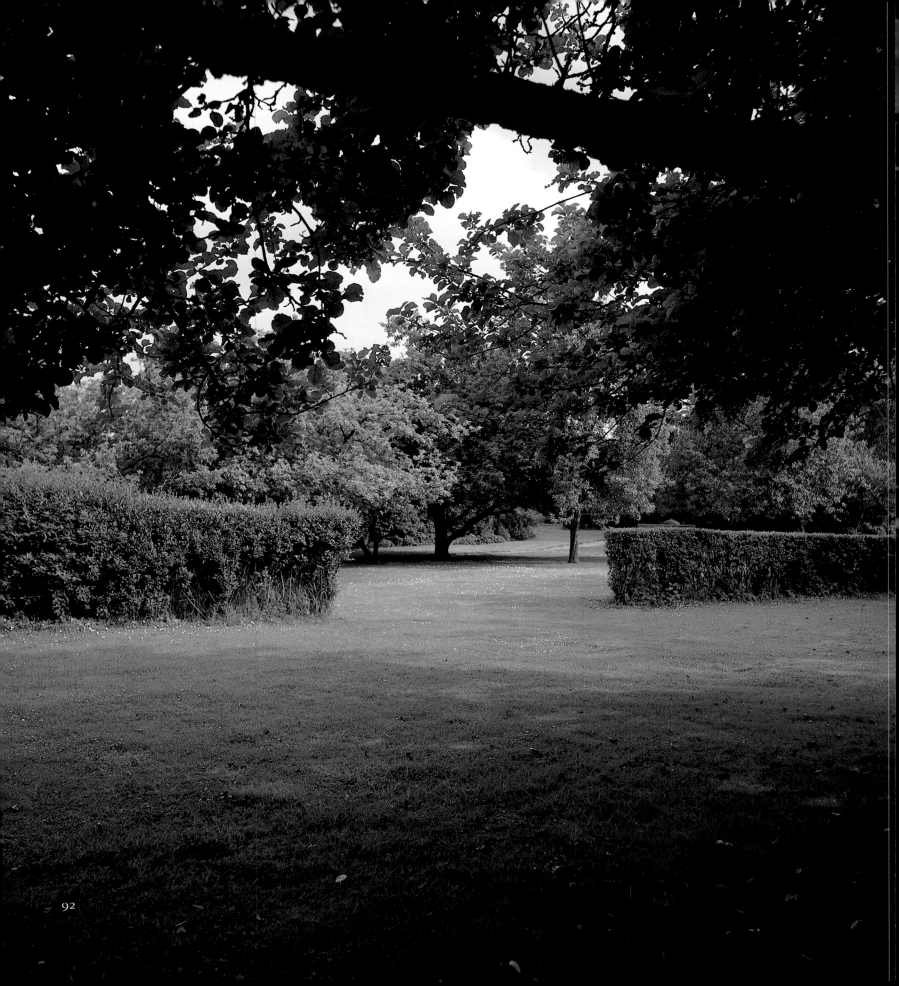

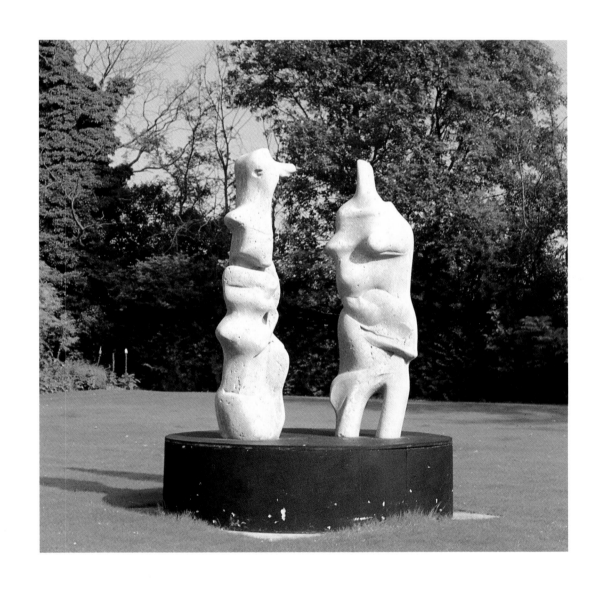

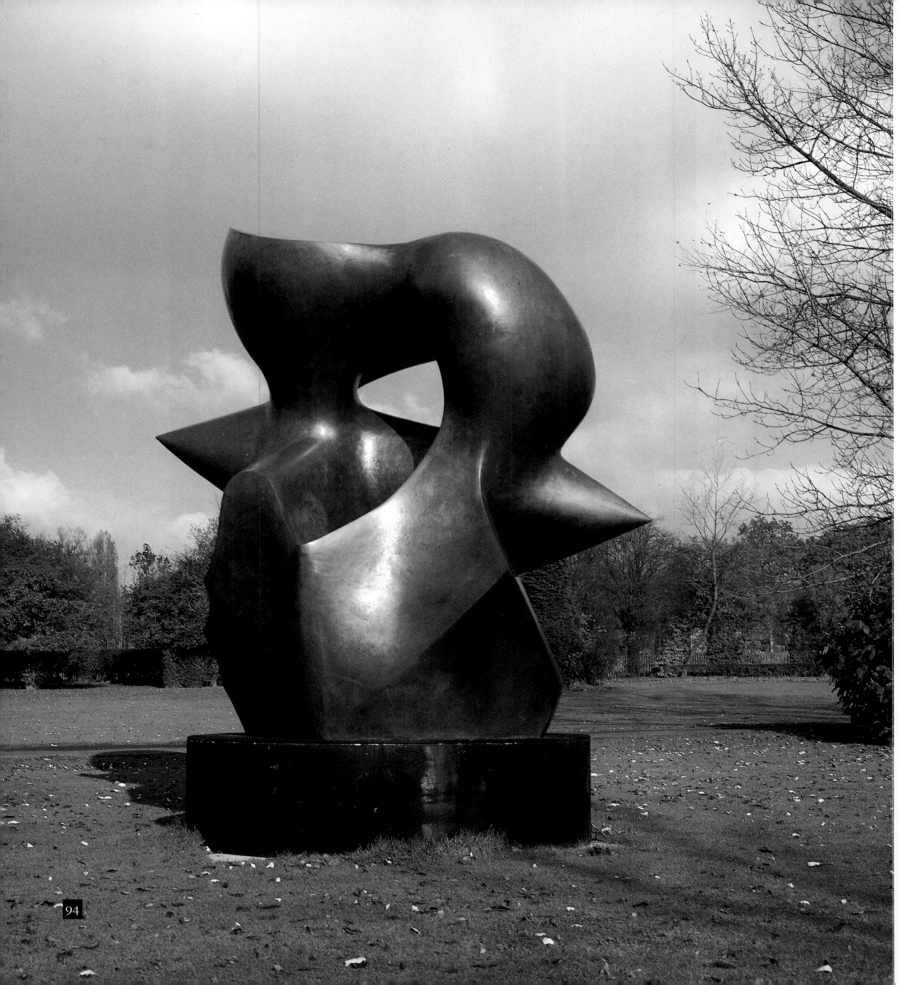

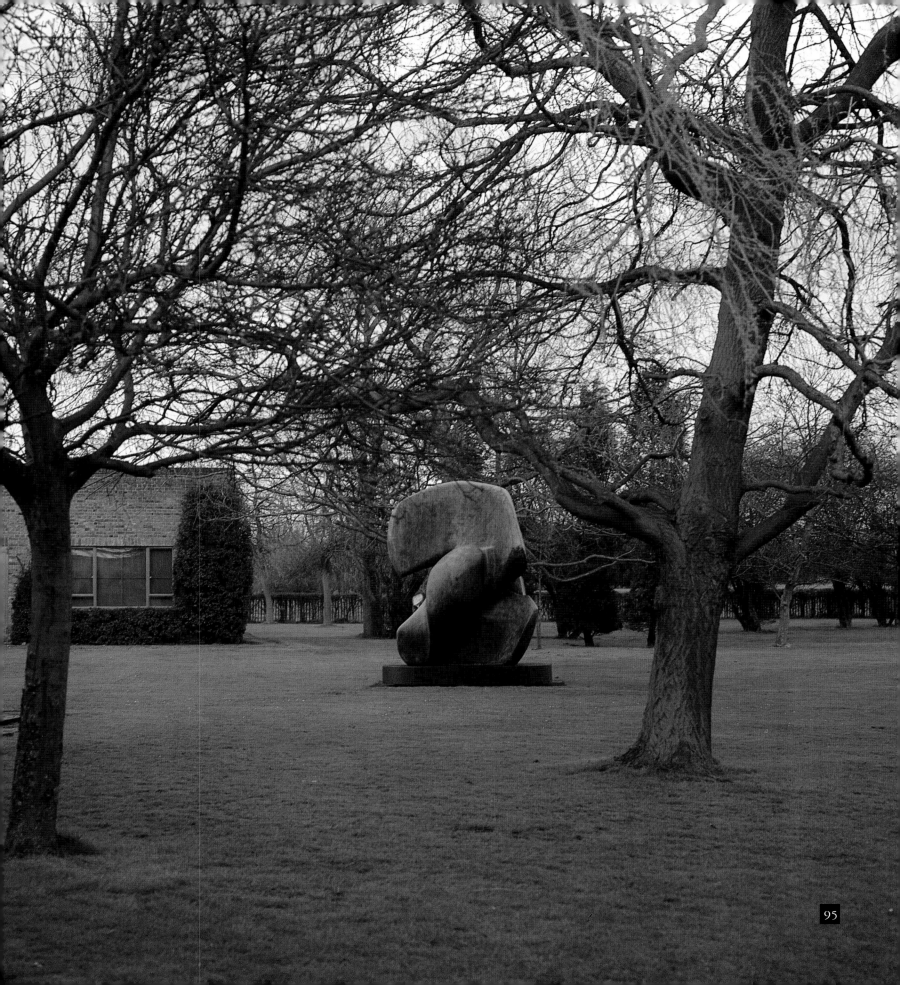

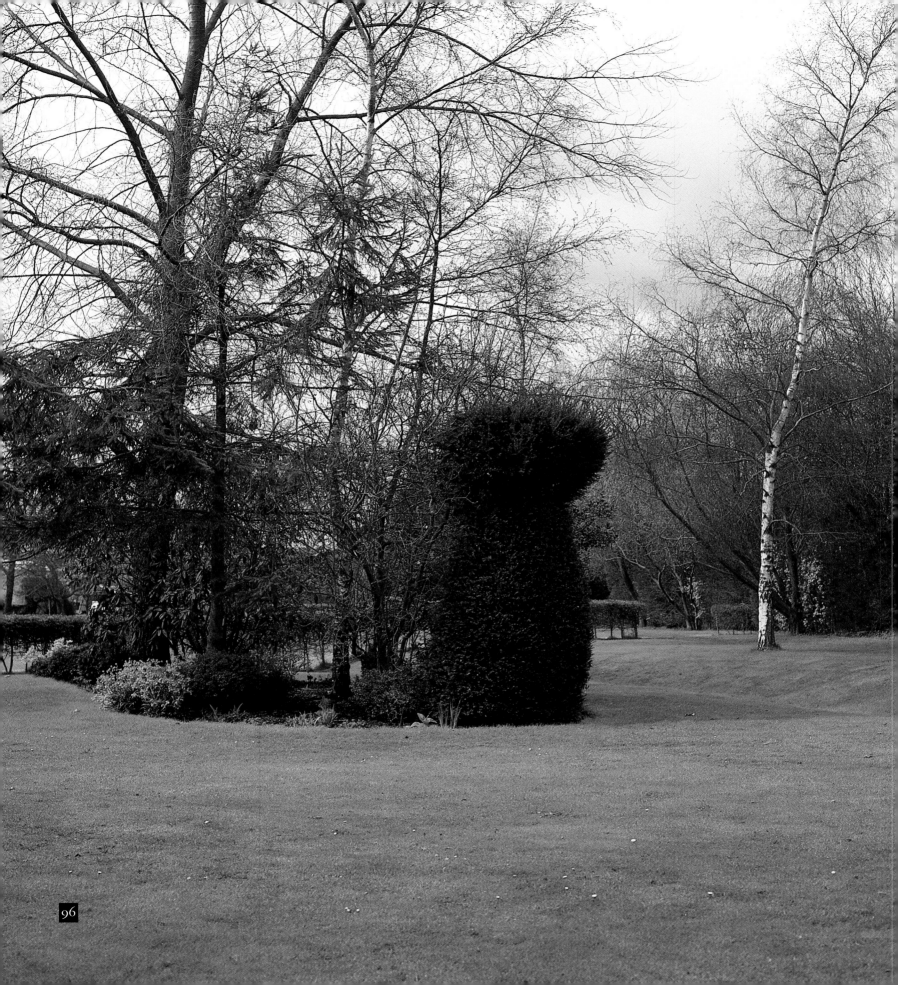

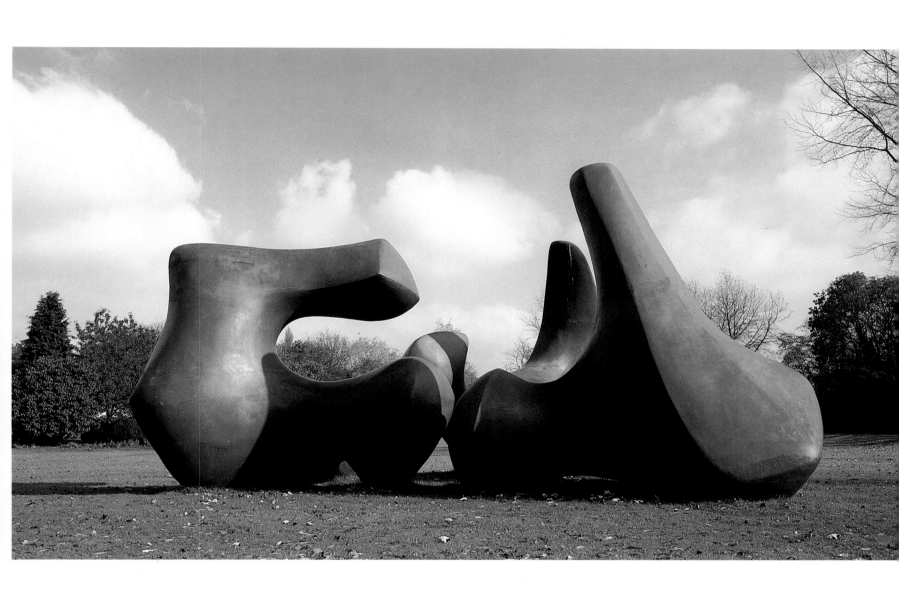

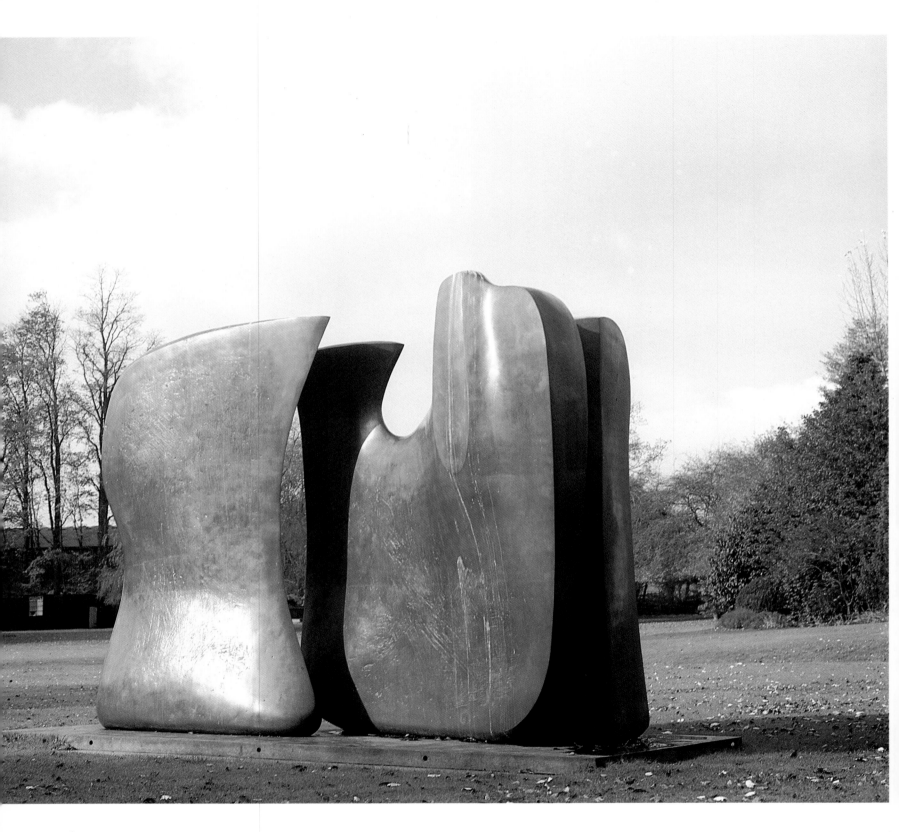

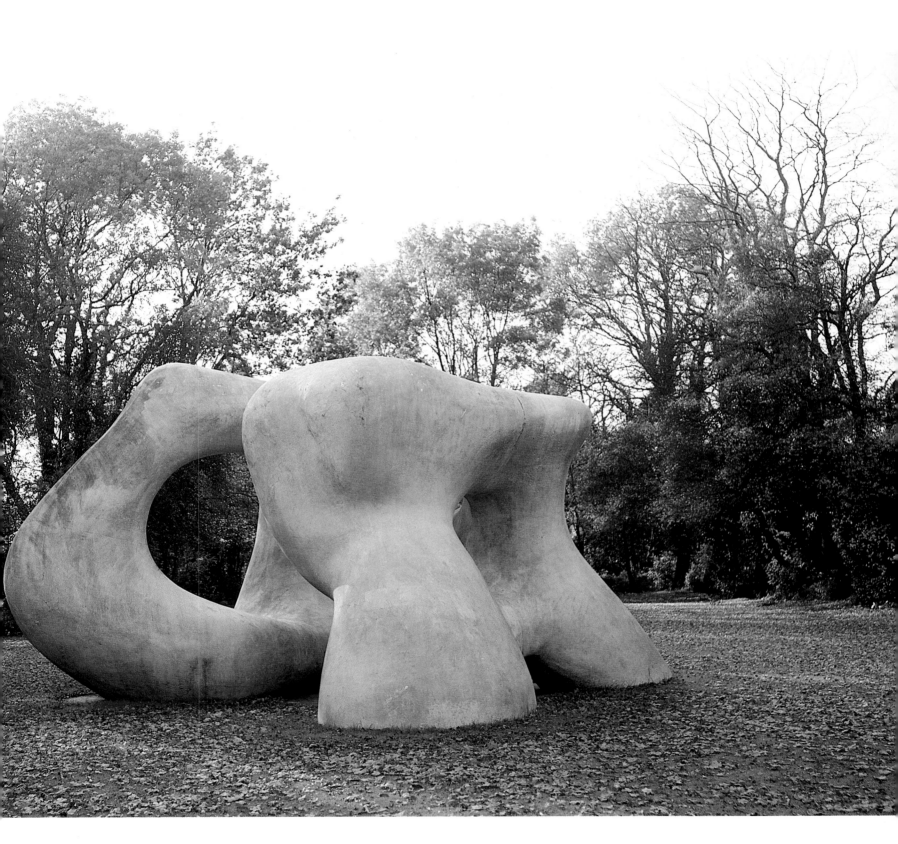

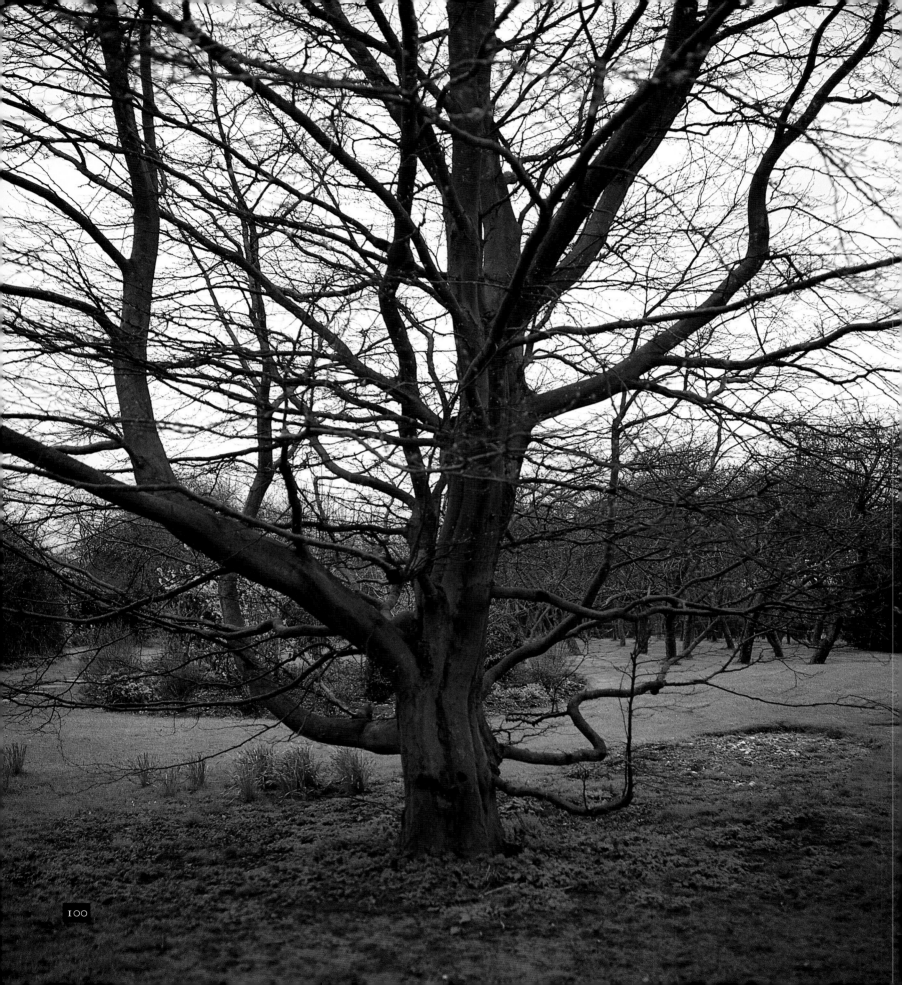

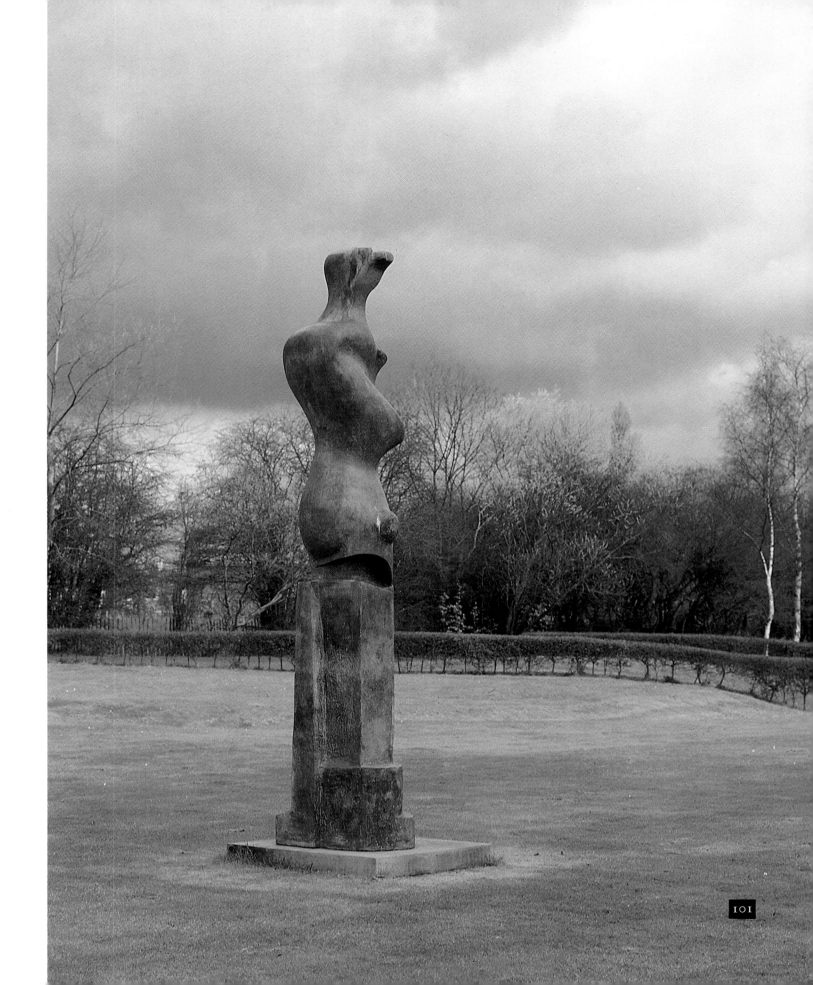

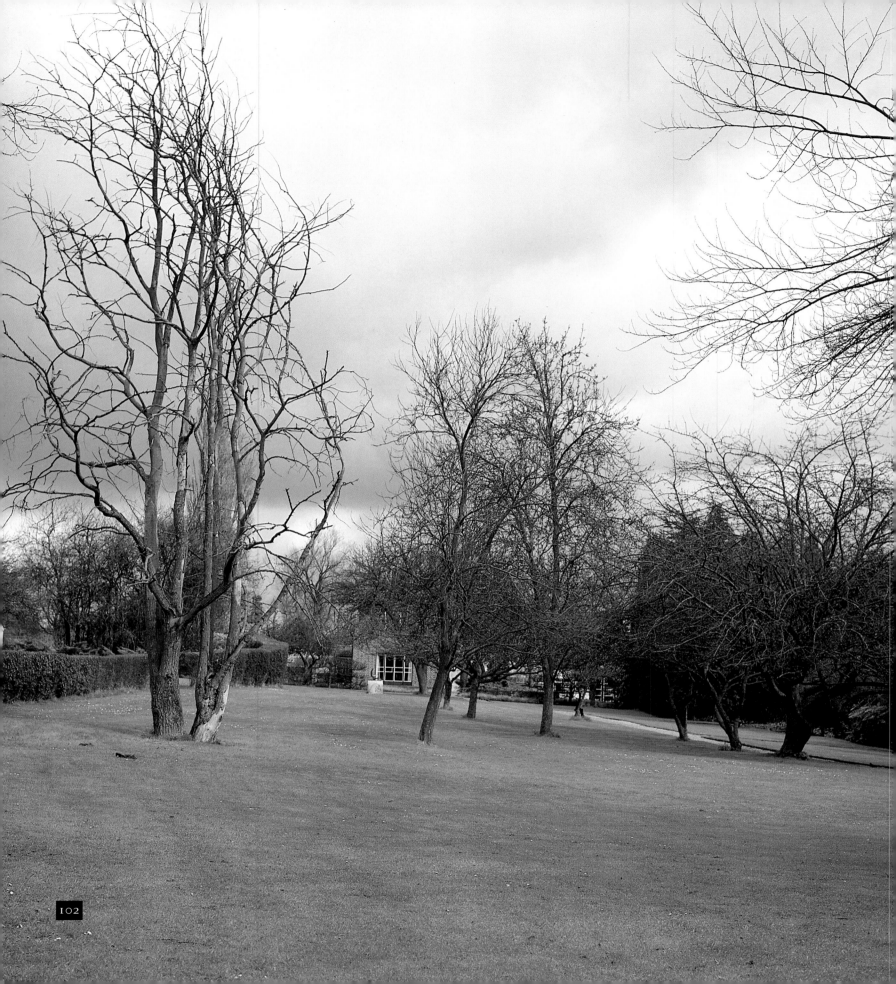

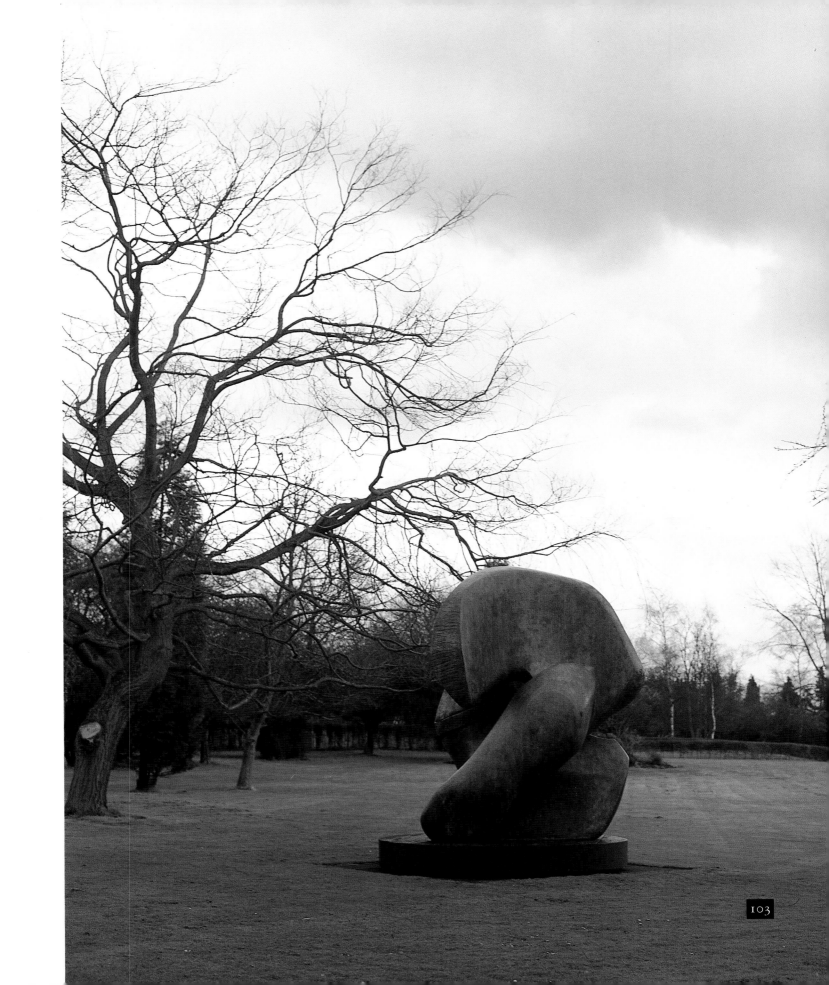

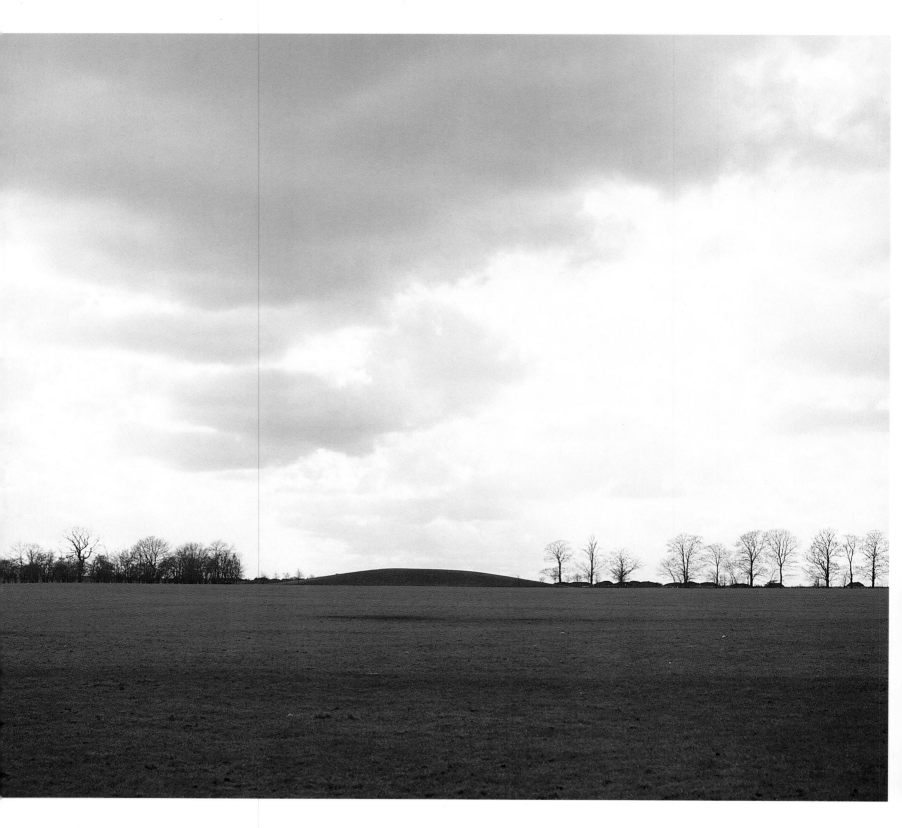

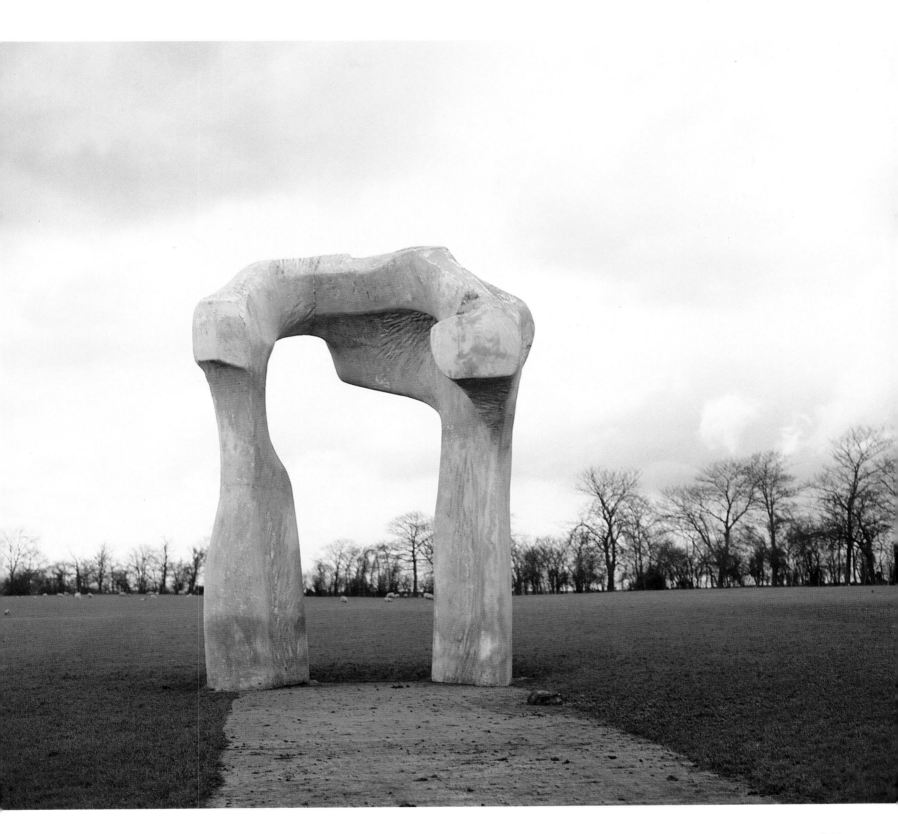

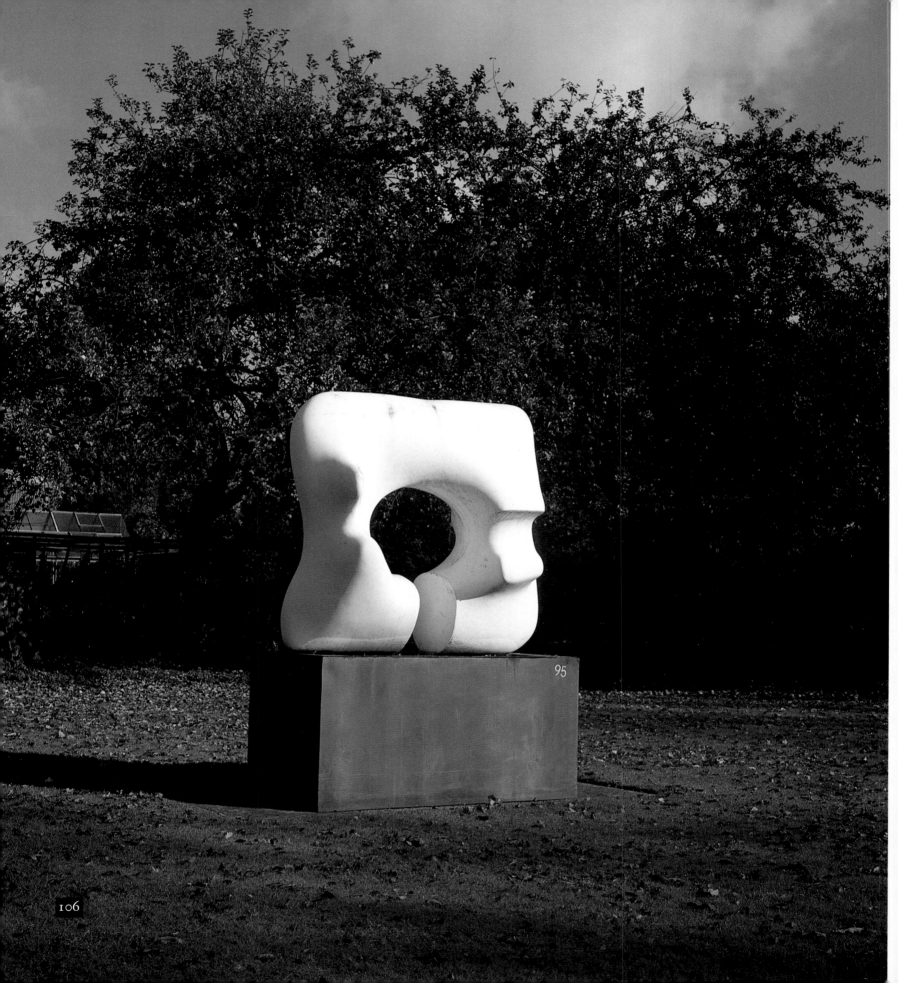

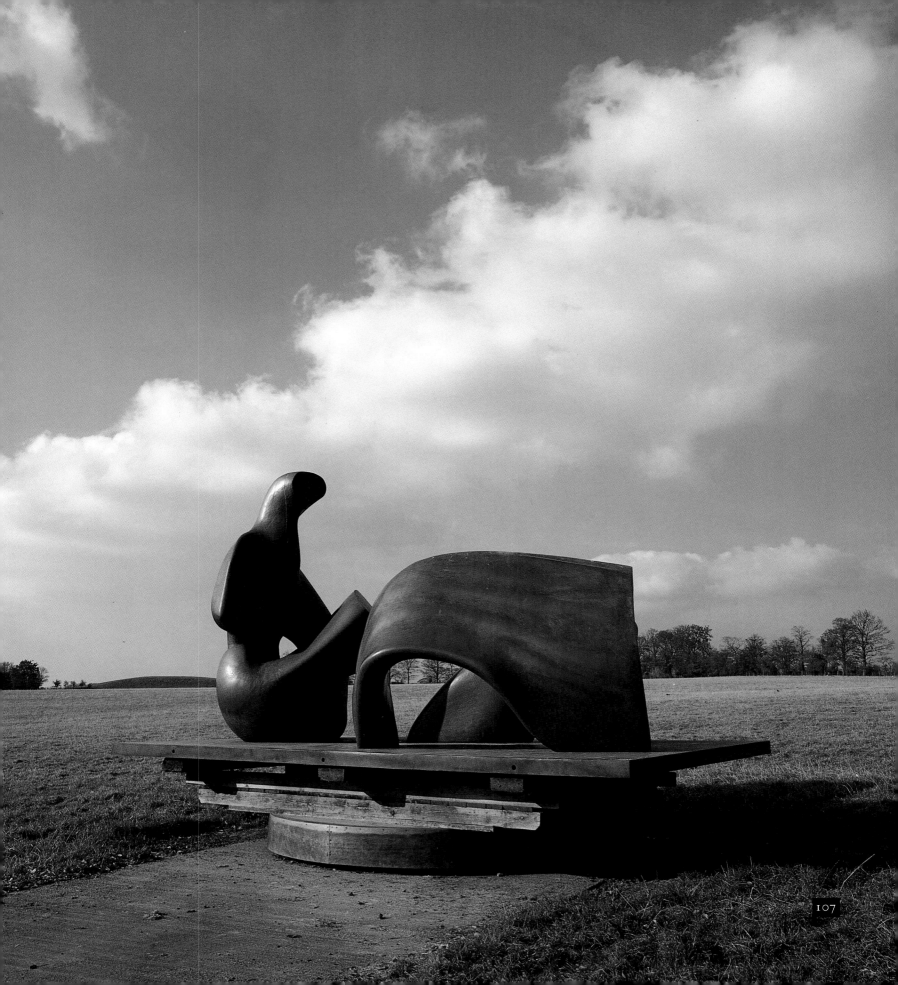

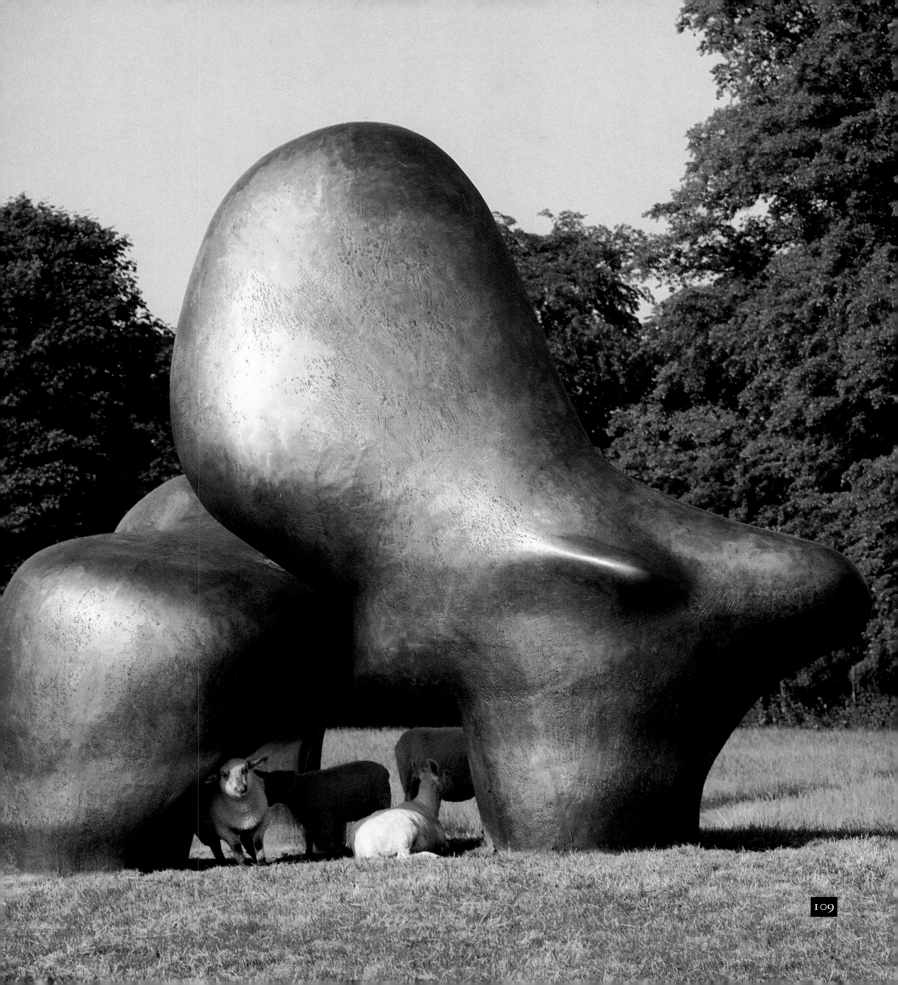

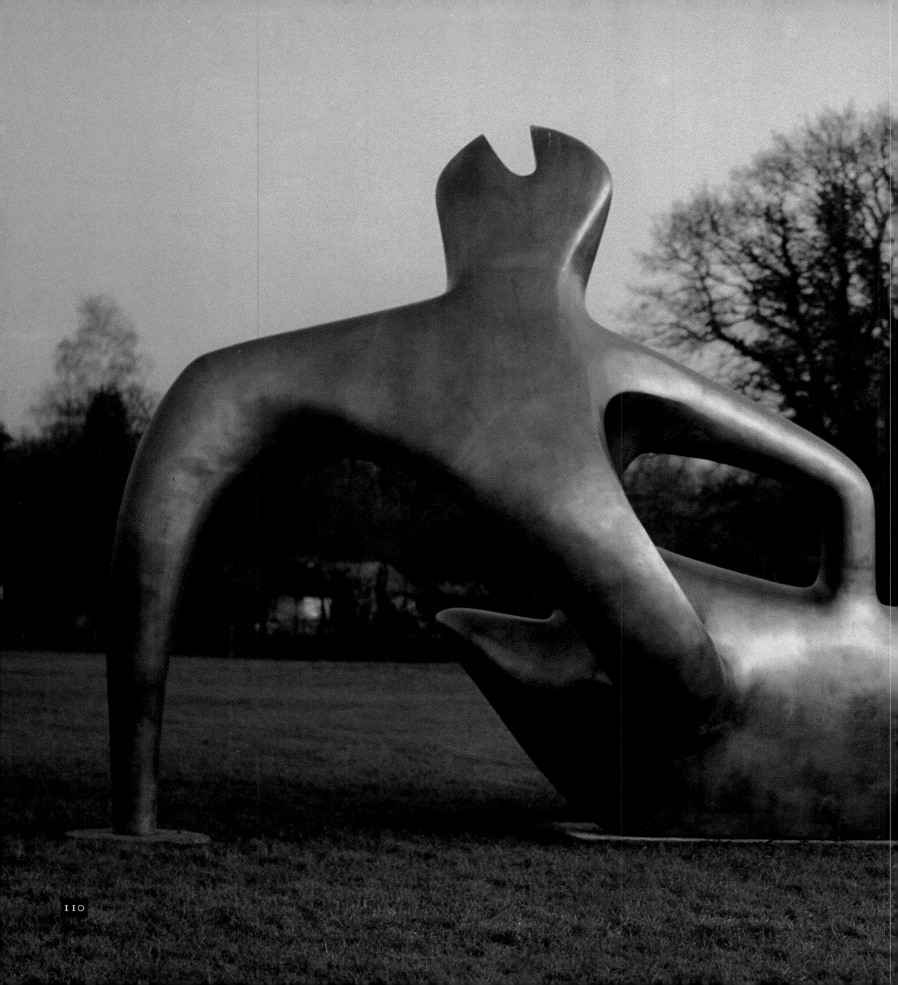

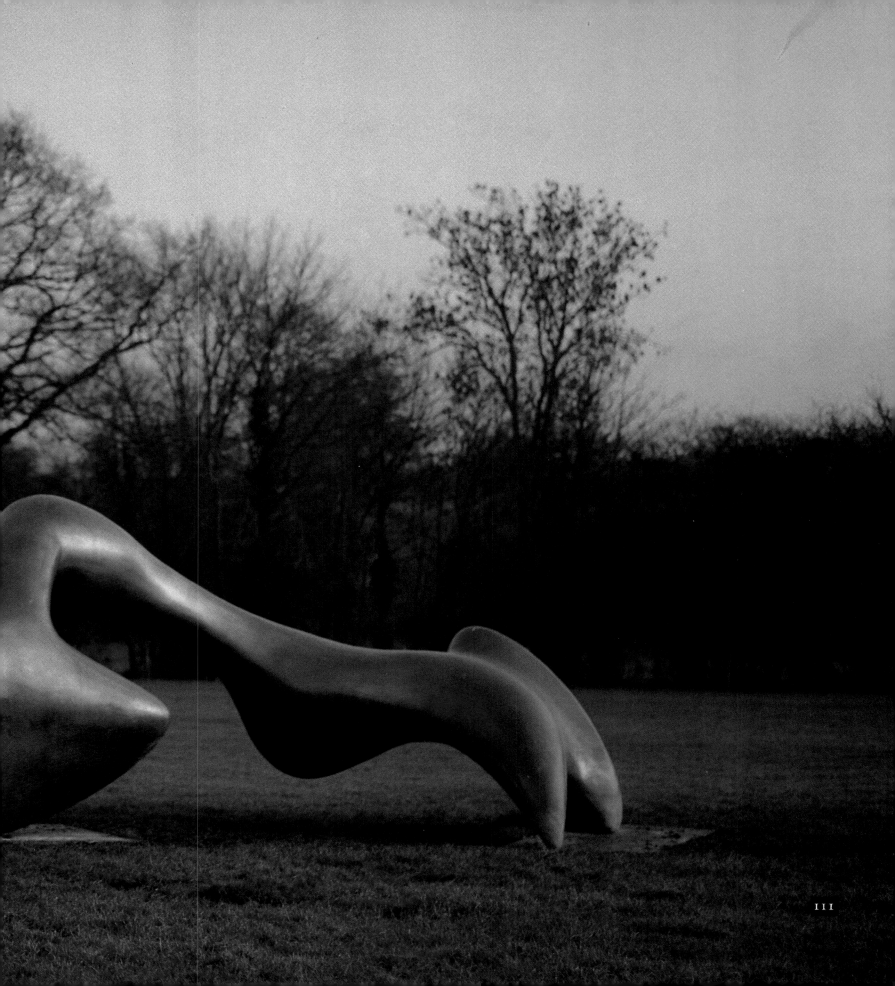

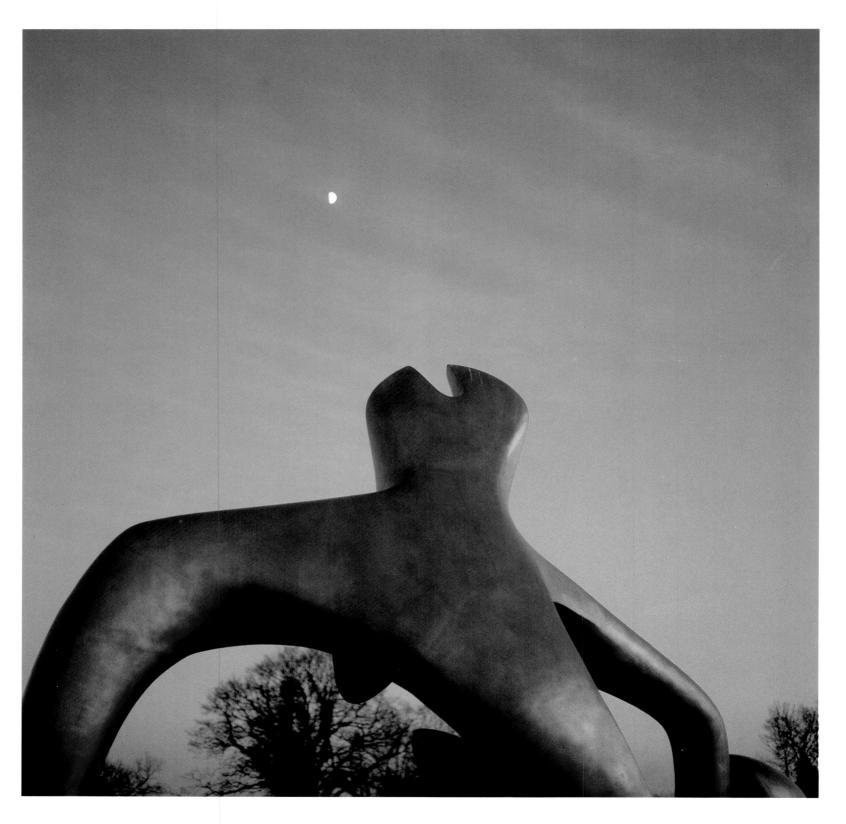

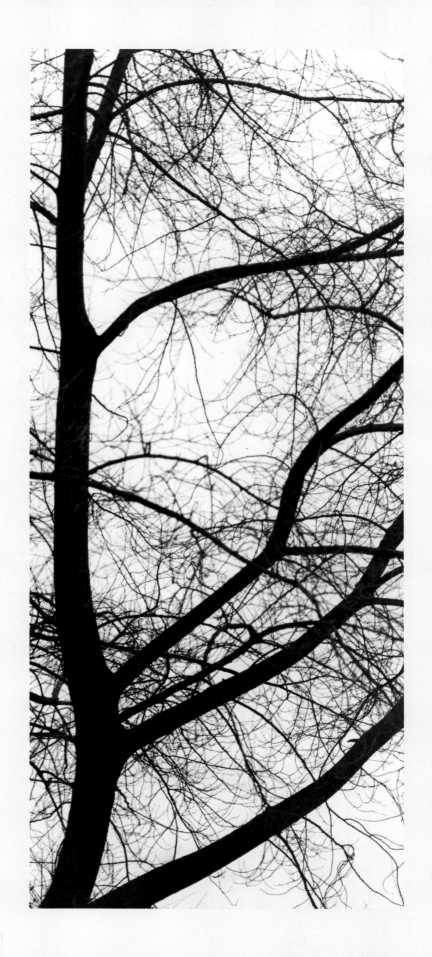

TREES IN THE GARDEN

*Henry Moore has always loved to draw the skeletal form
of winter trees. This series of photographs were taken at
Hoglands in the winter of 1984 as a gift for Moore, both
because I knew they were among his favourite forms and
also because I thought they might be source material for
new works. The two trunk fragments on pp. 124 and
125 were once drawn by Moore and are still preserved
outside his drawing studio.*

David Finn

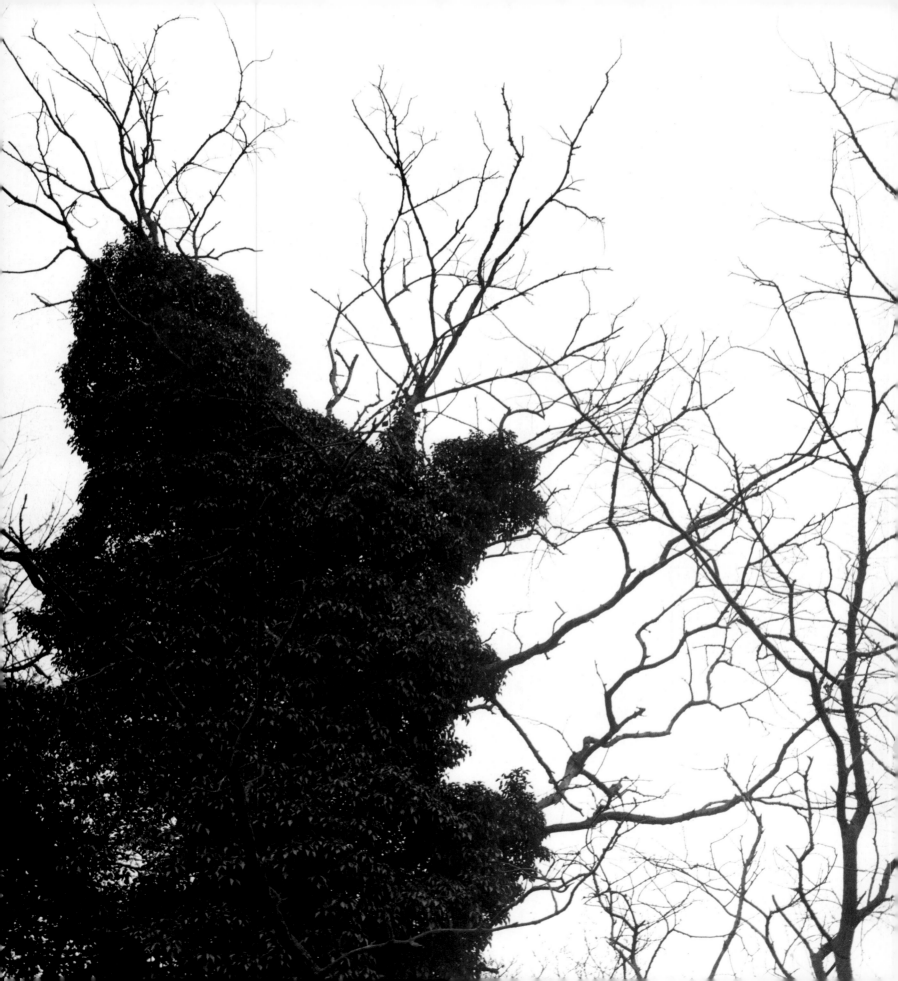

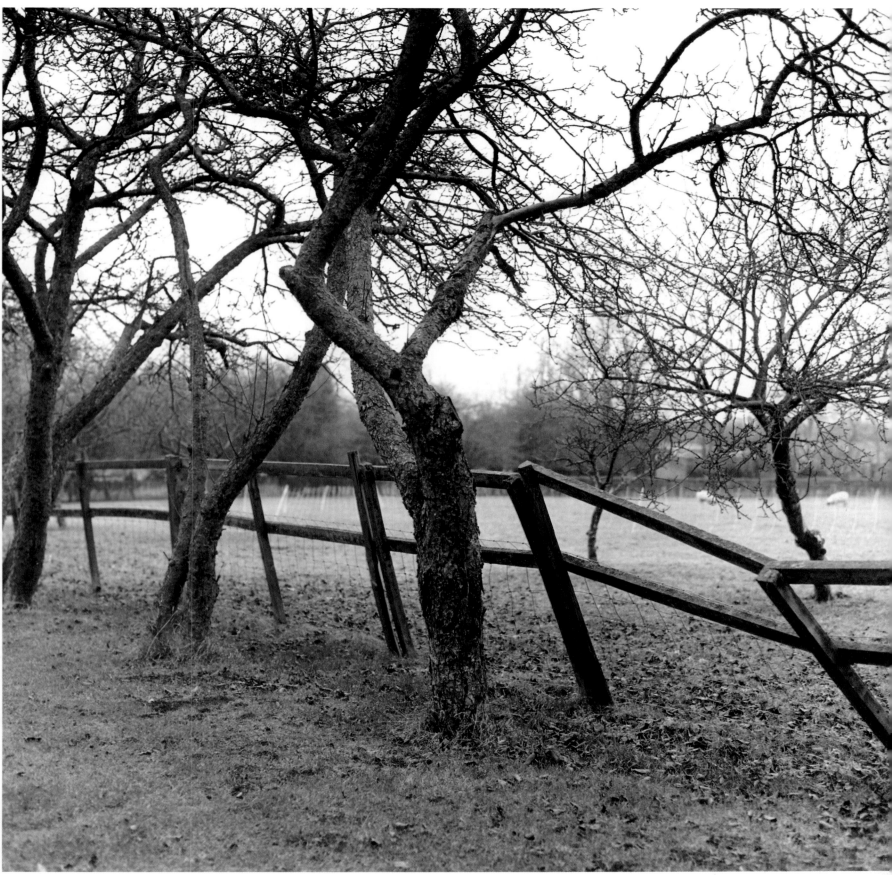

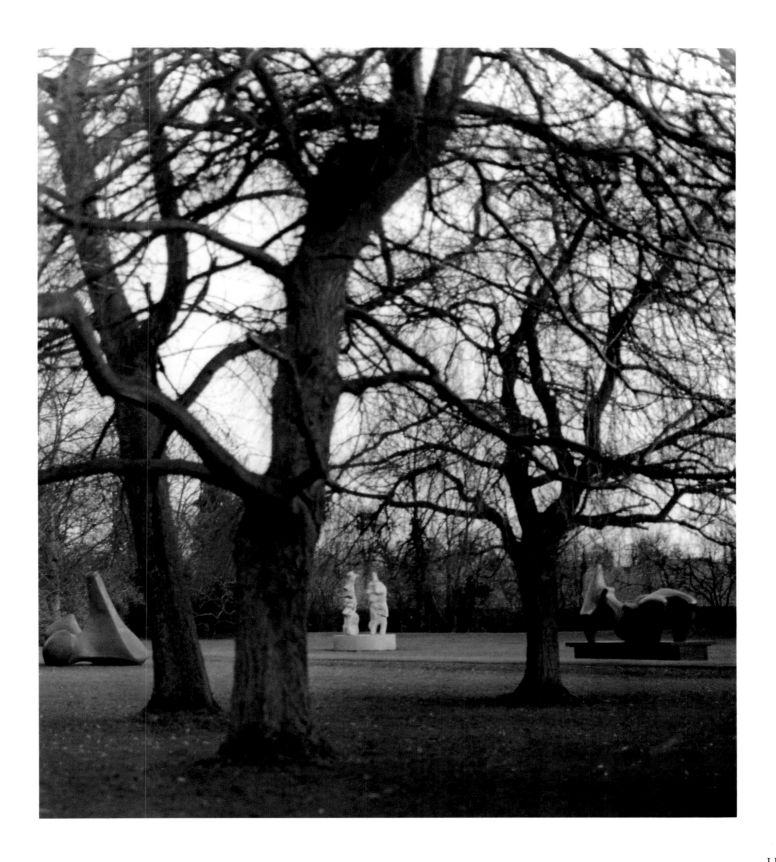

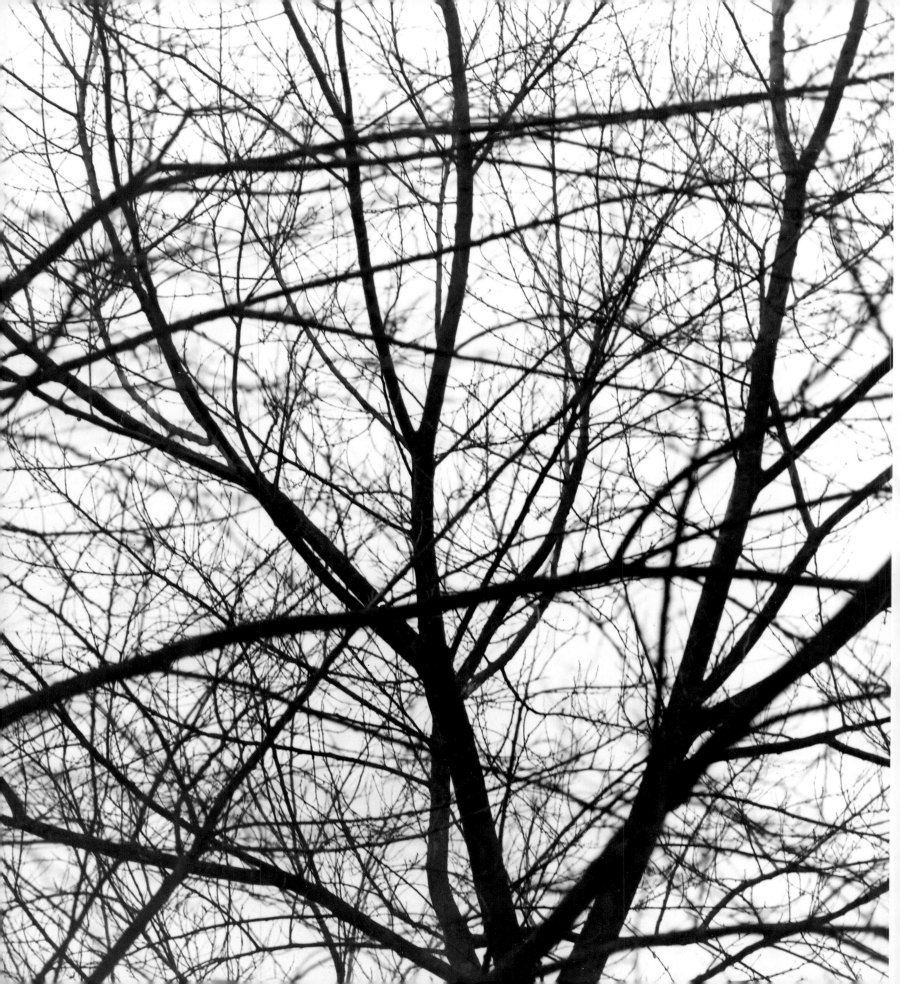

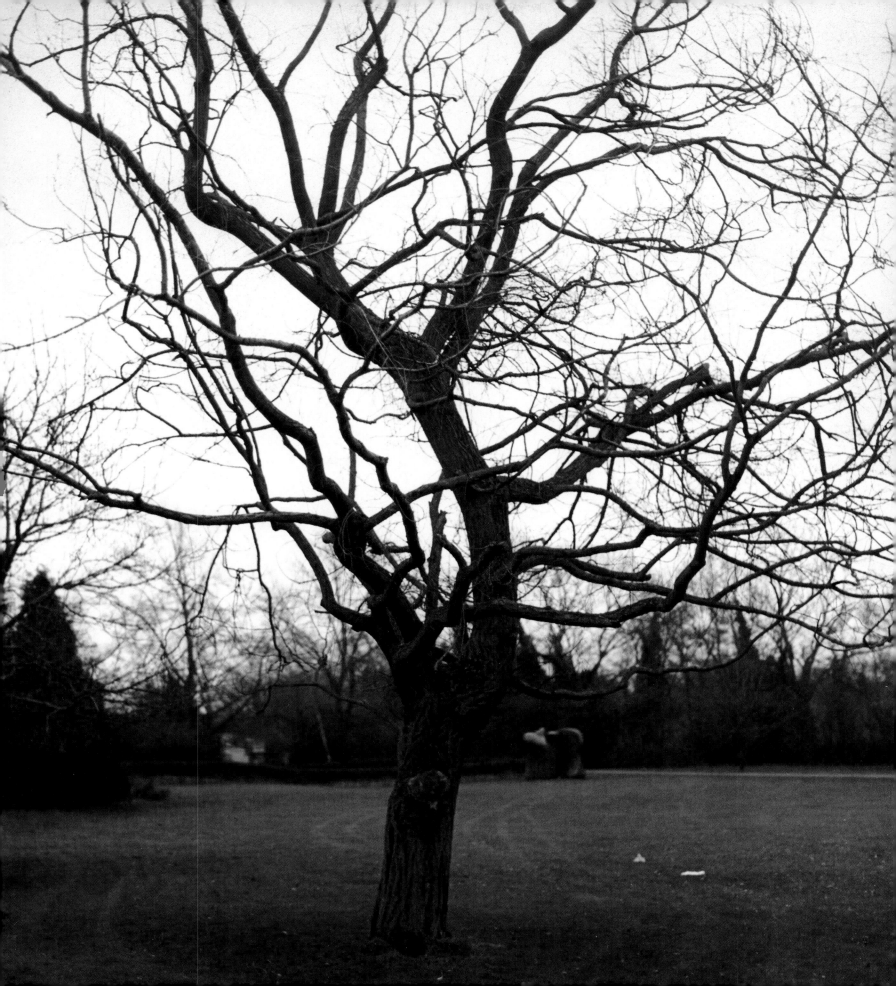

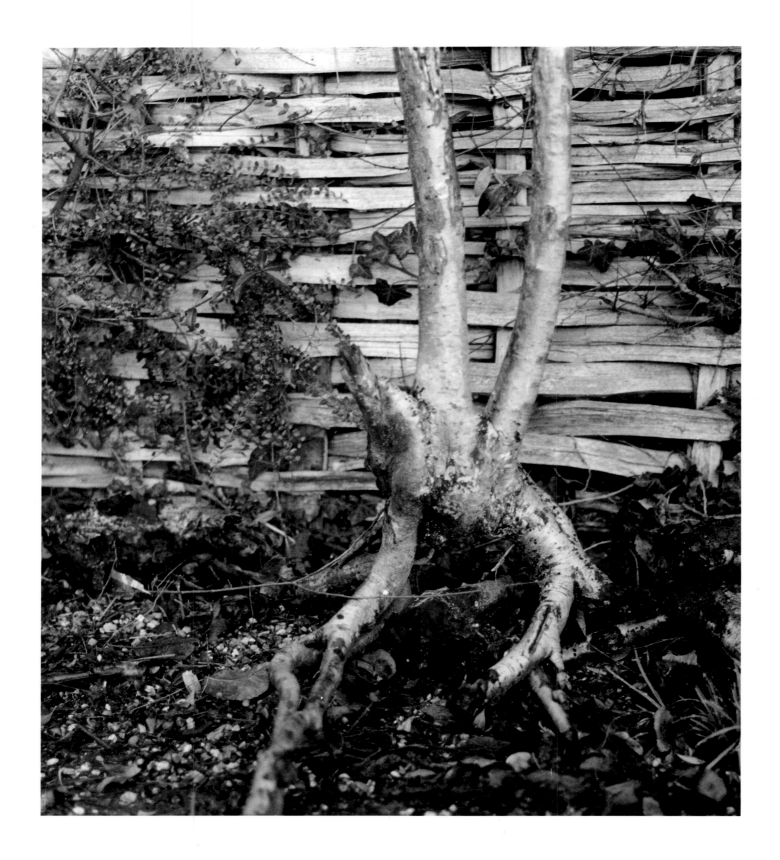

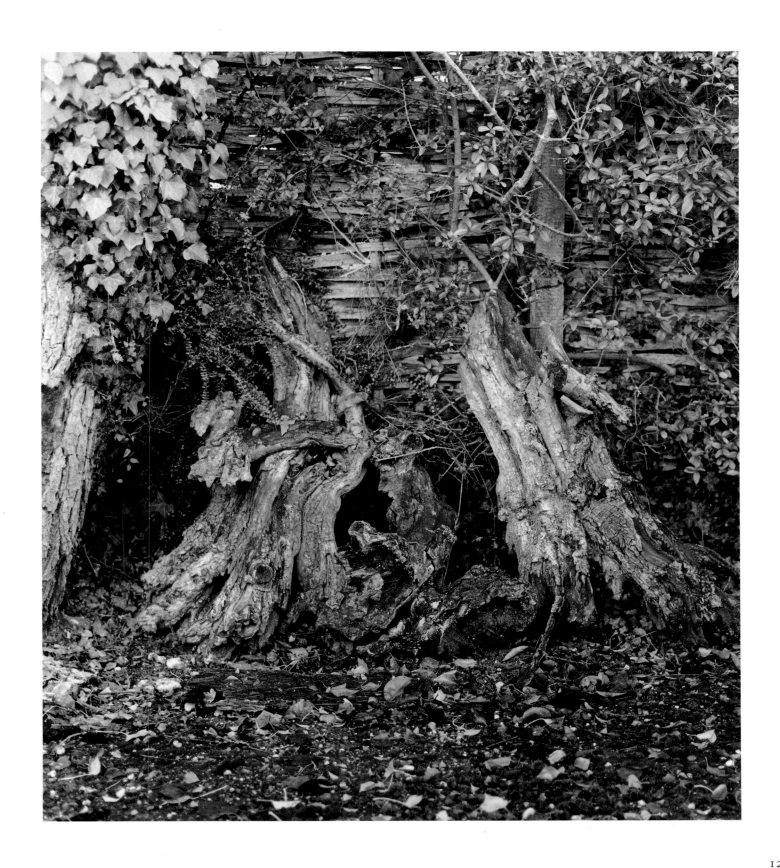

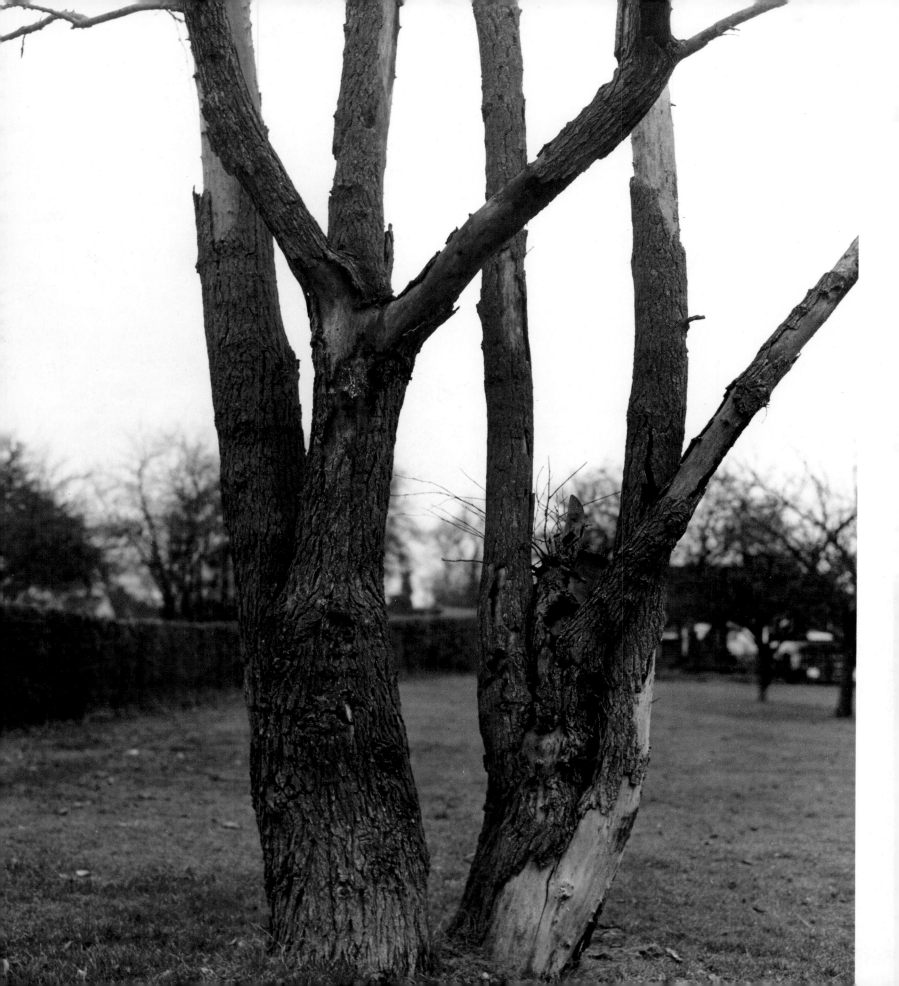

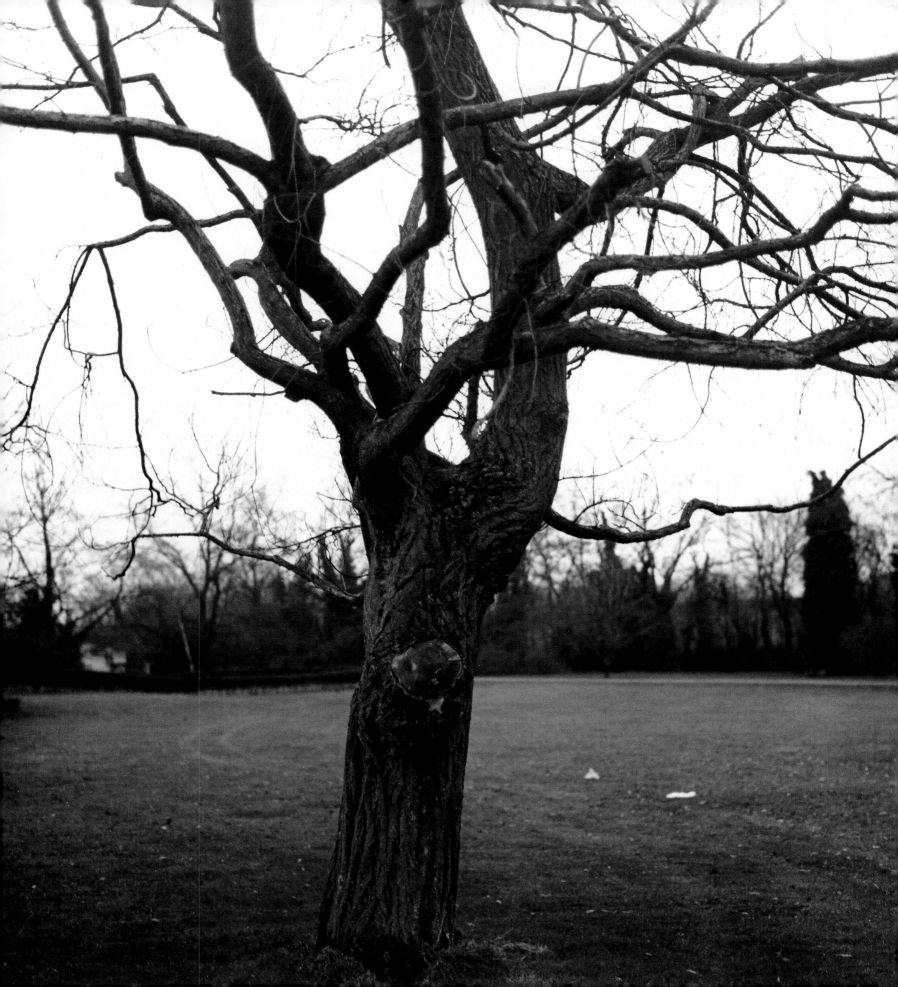

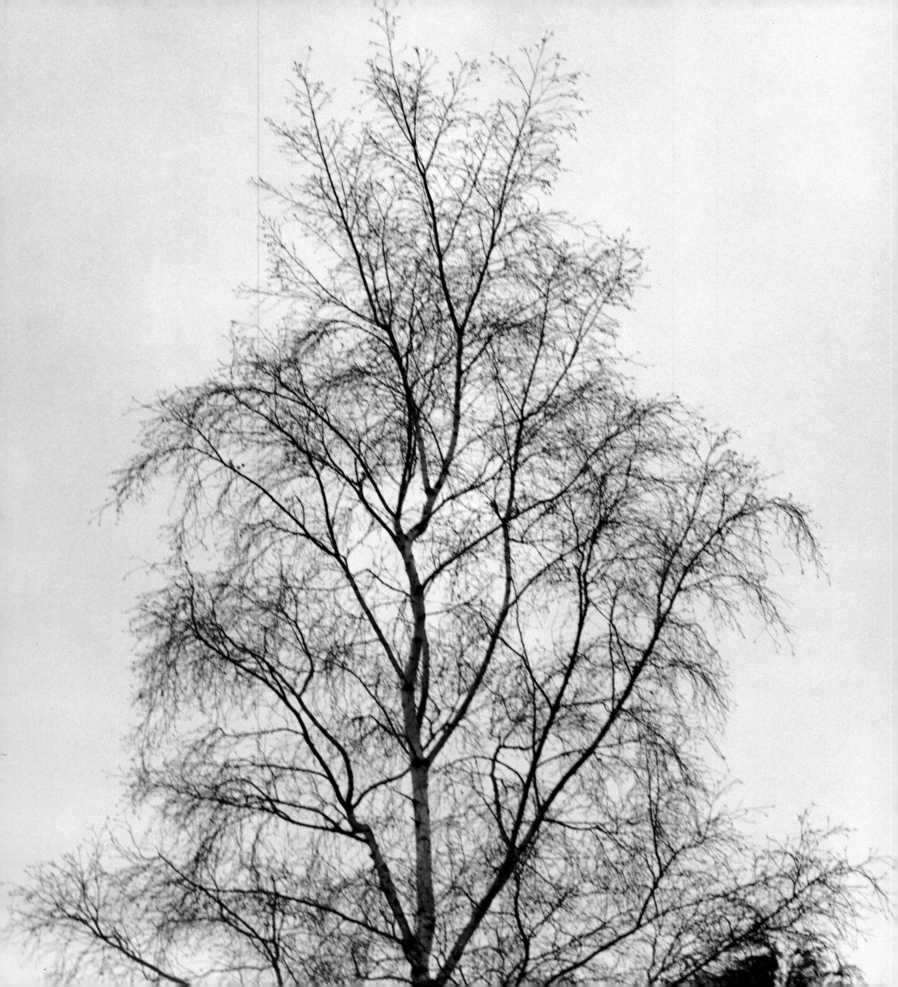

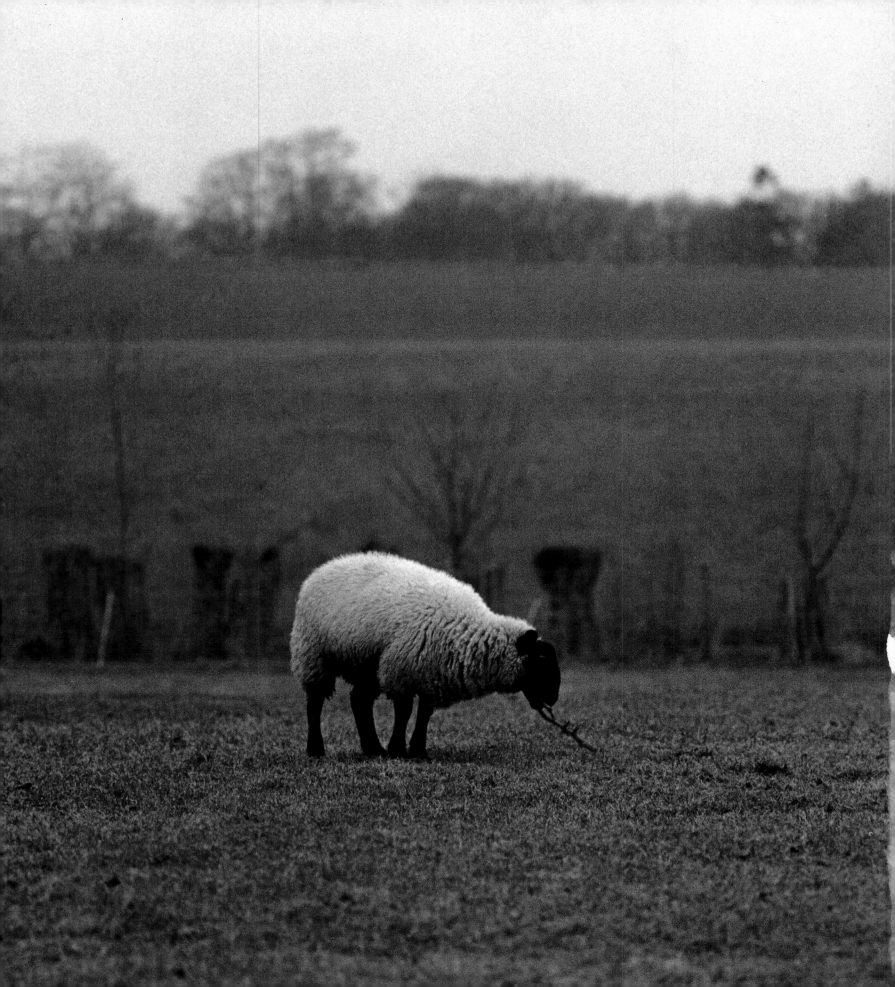